THE
MOVIE
PUZZLE BOOK

Quarto

Dr Gareth Moore would like to thank
Laura Jayne Ayres for her help in preparing
the many puzzles in this book.

First published in 2023 by Ivy Press,
an imprint of The Quarto Group.
One Triptych Place, London, SE1 9SH,
United Kingdom
T (0)20 7700 6700
www.Quarto.com

A catalogue record for this book is available
from the British Library.

ISBN 978-0-7112-8663-4
Ebook ISBN 978-0-7112-8664-1

10 9 8 7 6 5 4 3 2 1

Design by Dave Jones

Printed in China

THE
MOVIE
PUZZLE BOOK

Ian Smith
Dr Gareth Moore

IVY PRESS

Contents

Introduction

From its humble beginnings as a series of scientific experiments and infancy as a sideshow attraction, cinema rapidly transformed into one of the major artforms and dominant entertainments of the twentieth century.

A natural progression from the invention of the camera, the moving image has its roots in discoveries and experiments going back millennia. Cave paintings show evidence of early humankind attempting to represent the movement of animals. Chinese, Arabic and European scientists explored the world of optics, creating instruments such as the camera obscura – a way of projecting the world on to a wall. By the nineteenth century, rapid developments and discoveries with photographic materials saw the camera emerge. Some pioneers continued to develop technology until it was capable of capturing the moving image.

THE BIRTH OF CINEMA

On 28 December 1895, at Salon Indien du Grand Café in Paris, a paying audience witnessed the unveiling of an invention by Auguste and Louis Lumière. The *cinématographe* showed ten moving images of the outside world, projected on to a screen. The event did not mark the 'birth' of cinema – on 14 October 1888, French inventor Louis Le Prince had shot a 1.66-second film in the garden of a house in Roundhay, a suburb of the English city of Leeds. It remains the oldest-known film. However, the Lumières' event is where cinema as we know it began.

The brothers called their ten, single-shot sequences 'actuality films', mostly comprising documentary footage of everyday life. The theatre magician Georges Méliès saw the screenings and tried to buy a cinematograph from the Lumières. When they

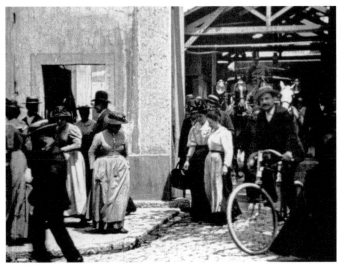

Workers leaving the Lumière factory (1895)

refused, Méliès made his own. He brought illusion and wonder to film, his rudimentary special effects a portend of what would come as the medium developed. And develop it did, around the world, in myriad ways that reflected and inspired cultures, peoples, art movements, ideologies and trends in entertainment.

THE UNIVERSE ON A SCREEN

This book takes you through 130 years of cinema, from early forays into comedy, drama, art and experimentation, to the modern age, where films play on screens the size of buildings or the palm of your hand. It journeys through the filmmaking process, from the kernel of an idea, presented in a pitch, through the screenwriting process, the shoot, editing and post-production, to the way that films are marketed and rewarded, either at the box office or through festivals and awards ceremonies. The book looks at the panoply of genres that have emerged over time, considers how film trends developed, and charts the rise of national cinemas and the emergence of stars. It explores the way films are shot, where they're shot and who shoots them – from the comic genius of Buster Keaton and the thrills of Alfred Hitchcock to the heightened emotions of Pedro Almodóvar, sly satire of Bong Joon-ho and subtle cadences of Céline Sciamma. As you read your way through, you'll find puzzles and quizzes that put your film knowledge to the test.

1

The Pitch

In the opening scene of US director Robert Altman's Hollywood satire *The Player* (1992), a lengthy single shot journeys around an LA film studio lot. Griffin Mill is the most successful producer there and over the course of eight minutes we see him in several encounters with screenwriters and executives who present their ideas to him. One describes their film as '*Out of Africa* meets *Pretty Woman*' as a way of convincing him to back their project. These are pitches and have been a constant in the life of a film since the early days of commercial cinema.

Once a film script is ready to be shot – by which point it will have gone through countless drafts – it is the job of the screenwriter, their agent, or a producer who may be attached to the film to secure the funding to make it. In the early days of cinema, a pitch may have been a brief outline. With the passage of time and increasing budgets, the process has become more complex. Adaptations, sequels and films based on TV shows prove popular with major studios looking for a blockbuster franchise – there is already an audience out there waiting to see what the movie version will be like. Genre is another major area where audience interest could be gauged. Since the 1930s, films have reflected tastes in a variety of genres. The introduction of sound in the late 1920s saw the musical become an attraction. Gangster films were popular in the early 1930s and westerns hugely so between the 1940s and 1960s. In more recent years, horror and superhero franchises have dominated. And then there are the hybrids, films that blend two genres to appeal to a broader base.

THE SCRIPT

The earliest films were brief snippets of action that captured everyday life. Late-nineteenth-century French cinema pioneers Auguste and Louis Lumière called them 'actuality films' – snapshots of the world around them.

But by the early twentieth century, short fictional scenarios began to attract audiences. Intertitles – on-screen text cards – embellished on the action or reported the dialogue of a conversation. As these short films gave way to feature-length attractions, the first of which was the 1906 Australian crime drama *The History of the Kelly Gang,* narratives became increasingly complex and sophisticated.

The coming of sound in the late 1920s saw dialogue-driven scripts replace intertitles. If pre-sound cinema was entirely driven by visuals, synchronized sound brought more focus to performance and what was being said, sometimes at the expense of what audiences saw. The industry attracted skilled writers, from journalists to novelists and playwrights, who honed their craft on transforming this new medium into an artform.

The way that films have been made over the decades has changed, through the introduction of new technologies and shifting styles – whether it's the mainstream, the artful or the experimental. Writers may pen their screenplays by computer rather than typewriter or by hand, and the format has been streamlined through the creation of software packages like Final Draft. But the dynamic between script, direction and acting remains the same. The words on the page are just one facet – albeit a vital one – upon the larger landscape of film production.

John Turturro in Joel and Ethan Coen's *Barton Fink*

THE POWER OF LANGUAGE

Match each of the following films with the language in which its dialogue was mostly written and performed. The languages have been anagrammed to make this a little trickier, and the two lists are not given in the same order.

Movies

1. *Parasite* (2019)
2. *The Seventh Seal* (1957)
3. *Seven Samurai* (1954)
4. *Pan's Labyrinth* (2006)
5. *The Hunt* (2012)
6. *The Lives of Others* (2006)
7. *City of God* (2002)
8. *Life is Beautiful* (1997)

Languages

A. UPSET ROGUE (10)
B. HAD SIN (6)
C. MANGER (6)
D. IN A TAIL (7)
E. APE JEANS (8)
F. EARN OK (6)
G. ASH SPIN (7)
H. SWISHED (7)

- -

SCREENPLAY TRIVIA

1. Which 1974 Best Original Screenplay Oscar winner told the story of water shortages in 1930s Los Angeles and is famous for its ending set in the place the film is named after?
2. *Sunset Boulevard* (1950) famously featured a character who told his story from beyond the grave. Which 1999 satire of US family life played a similar trick?
3. Which actor first won the Best Original Screenplay Oscar for his 1941 portrait of a power-hungry magnate?
4. Greta Gerwig wrote and directed an adaptation of Louisa May Alcott's *Little Women* in 2019. How many big screen adaptations have there been altogether – four, six or seven?
5. Joel and Ethan Coen wrote *Barton Fink* (1991), a film about writer's block, when they had writer's block on their previous film, a 1930s gangster drama. What was the title of that 1990 film?

CRIME

In cinema, crime pays. One of the medium's oldest genres, the crime film started out as an extension of the pulpy novels that became popular at the end of the nineteenth century. The earliest known example of a crime film is the 45-second long *Sherlock Holmes Baffled* (1900), but by the 1910s the genre was popular in most film-producing countries. France during this era was particularly notable, thanks to the crime serials *Fantômas* (1913–14), *Les Vampires* (1915–16) and *Judex* (1916), directed by Louis Feuillade.

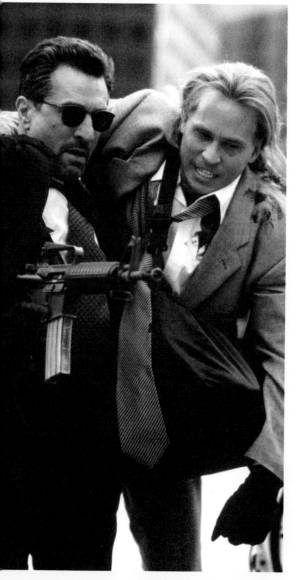

In the early 1930s, fuelled by stories of Prohibition-era mobster rule in Chicago, Hollywood turned the gangster genre into box office success. Warner Bros. Studios excelled at creating iconic hoodlum figures in films *The Public Enemy* (1931), *Little Caesar* (1931) and *The Petrified Forest* (1936), which made stars of James Cagney, Edward G. Robinson and Humphrey Bogart. At the same time, French and British cinema were also attracting audiences with tales from the underworld.

In the decades since, a series of cinematic crime waves has played well to audiences and earlier generations of filmmakers influenced later ones. For instance, the cool, detached, existential dramas of French filmmaker Jean-Pierre Melville, who created such classics as *Bob le Flambeur* (1956) and *Le Samouraï* (1967), can be seen in the later films of John Woo, one of the Asian directors whose 'bullet ballets' shaped the crime films of the 1980s and 1990s, and Michael Mann, whose *Thief* (1981) and *Heat* (1995) are now regarded as archetypal of the genre. Films by Martin Scorsese, the Coen brothers, Quentin Tarantino and David Fincher continue the legacy of this tried-and-trusted genre, while Rian Johnson's *Knives Out* (2019) saw a welcome revival of the classic whodunnit.

Robert De Niro and Val Kilmer in Michael Mann's *Heat*

DOUBLE LIVES

Each of these well-known crime films, all with a one-word title, has had extra letters added to disguise its true identity. Delete one letter from each pair to reveal the titles, and then match each movie with the name of a leading character and the actor who played them.

1. **DC EH IO SN AE NT OI LW KN** (1974)
2. **WV RE RI ST IA NG OY** (1958)
3. **QG OU AO RD FP AE IL LO AN XS** (1990)
4. **RS CL OA RW KF AV CM YE** (1983)
5. **SP LE VR EU BN** (1995)
6. **KJ RO CK IE RL** (2019)
7. **WC OE DL LP IA CT EO MR NA LT** (2004)
8. **FG HA TR MG OS** (1996)

Lead characters

- **Arthur Fleck**, played by Joaquin Phoenix
- **David Mills**, played by Brad Pitt
- **Jake Gittes**, played by Jack Nicholson
- **James Conway**, played by Robert De Niro
- **Marge Gunderson**, played by Frances McDormand
- **John 'Scottie' Ferguson**, played by James Stewart
- **Tony Montana**, played by Al Pacino
- **Vincent**, played by Tom Cruise

- -

THRILLER TRIVIA

1. Before his success with the *Knives Out* series, Rian Johnson wrote and directed a time-travelling sci-fi crime thriller starring Bruce Willis and Joseph Gordon-Levitt. What was the name of the 2012 film?
2. What do the classic crime thrillers *Murder, My Sweet* (1944), *The Lady in the Lake* (1946), *The Big Sleep* (1946) and *The Long Goodbye* (1973) all have in common?
3. Which 1994 crime classic features the characters Vincent, Mia, Jules and Butch?
4. He has tattooed his body to remind him of who he is and what he is investigating. What is the 2000 film?
5. Tom Cruise is the hunter who becomes the hunted in which futuristic 2002 crime thriller?

THE WESTERN

The first narrative western is reckoned to be *Kidnapping by Indians* (1899), made by the British filmmakers Mitchell and Kenyon in the English town of Blackburn. But it is Edwin S. Porter's *The Great Train Robbery* (1903) that set the template for what became arguably the greatest American film genre.

Although it was intermittently popular during the silent period, it was in the late 1930s that the western came into its own, almost in tandem with the rise of John Wayne as a star. His breakthrough film, *Stagecoach* (1939) is regarded as one of the finest examples of the classic western. It was directed by John Ford, who, along with Howard Hawks, became one of the masters of the genre during Hollywood's Golden Age (1930s–1960s). That era also saw the rise of great western B-movies, lower budget films that nevertheless highlighted the brilliance of directors such as Anthony Mann, Budd Boetticher and Raoul Walsh.

The relaxation of Hollywood's moral code in the 1960s saw a new, more violent form of western emerge, defined by films such as Sam Peckinpah's *The Wild Bunch* (1969) and Ralph Nelson's *Soldier Blue* (1970). At the same time, the spaghetti western took the genre in a very different, more European, direction. Its key figure was Sergio Leone, whose Dollar Trilogy, culminating in *The Good, the Bad and the Ugly* (1966), made a star of Clint Eastwood. A stark contrast to Wayne, Eastwood represented a tonal shift from a Manichean good versus bad to something more ambiguous. This change also marked the genre's change in fortunes. It remains occasionally popular but no longer dominates the cinematic landscape the way it once did.

Clint Eastwood in Sergio Leone's *The Good, the Bad and the Ugly*

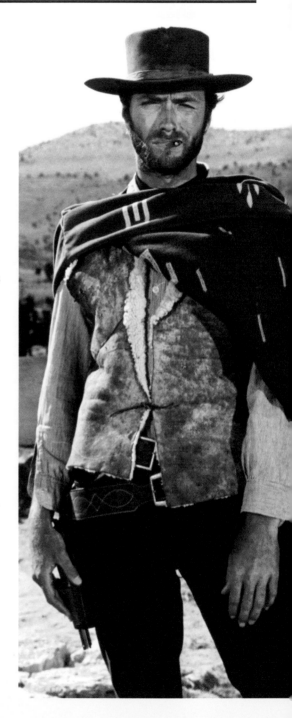

WESTERN LETTERFIT

Place the capitalized surname of each of these actors, famous for their roles in westerns, into the grid by writing one letter per box to read from left to right or top to bottom. Once all of the names are placed, the letters in the shaded squares can be rearranged to spell out the name (6, 5) of a notable director of 'spaghetti' westerns. Who is it?

- **Buster KEATON**
- **Charles BRONSON**
- **Clint EASTWOOD**
- **Eli WALLACH**
- **Gary COOPER**
- **Henry FONDA**
- **James STEWART**
- **Jeff BRIDGES**
- **Joel MCCREA**
- **John WAYNE**
- **Kurt RUSSELL**
- **Lee van CLEEF**
- **Marlon BRANDO**
- **Paul NEWMAN**
- **Robert REDFORD**
- **William HOLDEN**

THE SCREWBALL COMEDY

Take the physical dexterity of the greatest silent slapstick comedies, combine it with razor-sharp dialogue delivered at lightning speed, and you have the recipe of the screwball comedy. A form that became popular in the 1930s, the genre revelled in the potential of synchronous sound in cinema.

It grew out of films such as *She Done Him Wrong* and *I'm No Angel* (both 1933), fast-talking comedies featuring vaudeville performer turned risqué screen star Mae West, which undermined conventional mores. West's co-star in those films was Cary Grant who, along with Katharine Hepburn, would become one of screwball's most versatile performers. Their screen partnership is best exemplified in the madcap 1938 Howard Hawks film *Bringing Up Baby*, a fast-paced comedy about mistaken identity – a common trope in this genre. Hawks and Grant would team up again in 1940 for *His Girl Friday*, arguably the greatest screwball comedy. An adaptation of the

newsroom stage comedy *The Front Page* (1928), the film's dialogue isn't so much spoken as delivered like machine-gun fire.

Other key screwball comedies from the era include Clark Gable and Claudette Colbert in Frank Capra's *It Happened One Night* (1934), Grant, Hepburn and James Stewart in *The Philadelphia Story* (1940) and *Sullivan's Travels* (1941) and *The Lady Eve* (1941), both written and directed with flair and wit by Preston Sturges. The genre's golden period was over by the early 1960s, marked by Billy Wilder's Cold War-era comedy *One, Two, Three* (1961). It later resurfaced with Peter Bogdanovich's manic *What's Up, Doc?* (1972), which starred Barbra Streisand. And the Coen brothers have done much to revitalize the genre in films like *Raising Arizona* (1987), *The Hudsucker Proxy* (1994), *Burn After Reading* (2008) and *Hail, Caesar!* (2016).

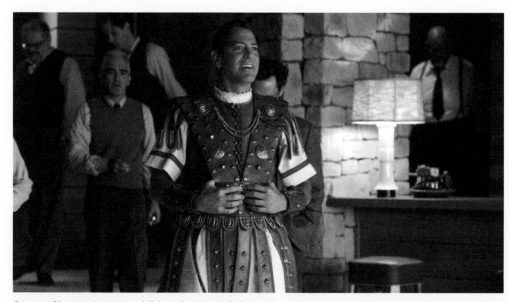

George Clooney in Joel and Ethan Coen's *Hail, Caesar!*

ONE-LINERS

What famous witticism was spoken by Mae West in response to each of the following lines? The witty ripostes are given beneath, labelled from A to F, but their words have been rearranged into alphabetical order.

1. 'I see a man in your life.'
2. 'I changed my mind.'
3. 'I've heard so much about you.'
4. 'Aren't you forgetting that you're married?'
5. 'I'll never forget you.'
6. 'What do you want to do, drive me to the madhouse?'

Responses

A. 'a call I'll no taxi you'
B. 'any better does it work?'
C. 'best doing I'm my'
D. 'but can't it prove yeah you'
E. 'does ever no-one'
F. 'one only what?'

MELODRAMA

With its combination of close-ups and wide shots, cinema is the perfect platform for capturing the full panoply of human emotions. Nowhere is this more evident than in the melodrama, arguably the most emotionally wrought of genres.

The American film director D.W. Griffith was one of the early pioneers of the form. The sweeping romance of *Way Down East* (1920) and the high drama of the French Revolution in *Orphans of the Storm* (1921) raised the bar for the genre in the pre-sound era.

In the 1930s and 1940s, the melodrama fell under the trappings of what was known as the 'women's picture' – films aimed directly at female audiences. With the arrival of the Second World War, the genre adapted to the times. Romance and high-stakes drama lay at the heart of *Casablanca* (1942), which unfolded on the front line of the conflict, while *Mrs. Miniver* (1942) and many other films like it detailed life on the domestic front.

In the same period, the UK's Gainsborough Pictures profited from a more lurid take on the melodrama, particularly in its series of bodice-ripping period costumers, such as *The Man in Grey* (1943) and the surreal *Madonna of the Seven Moons* (1944).

The melodrama found its most gifted connoisseur in German-born filmmaker Douglas Sirk. His *Magnificent Obsession* (1954), *All That Heaven Allows* (1955), *Written on the Wind* (1956) and *Imitation of Life* (1959), shot in richly saturated colour and pitched at a heightened level of human emotion, are regarded as the highpoints. Sirk influenced the work of subsequent filmmakers, such as German director Rainer Werner Fassbinder (*The Bitter Tears of Petra von Kant*, 1972; *Fear Eats the Soul*, 1974), acclaimed Spanish filmmaker Pedro Almodóvar (*All About My Mother*, 1999; *Volver*, 2006) and US director Todd Haynes (*Far From Heaven*, 2002; *Carol*, 2015).

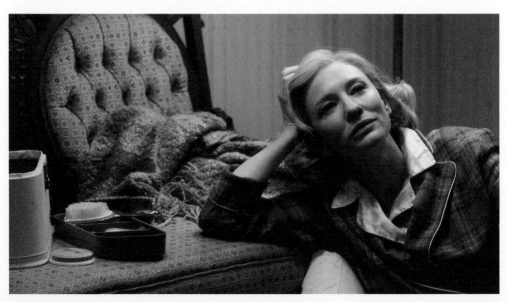

Cate Blanchett in Todd Haynes' *Carol*

THE CLOSE-UP

Beneath each film title below is a 'close-up' of that movie's leading lady, showing only part of their name. Can you mentally zoom out and reveal each actress's full name?

1. *Gone with the Wind*

2. *Casablanca*

3. *Volver*

HORROR

Cinema can unsettle, scare and shock. It can revel in the visceral or intimate unspeakable horror lurking in the darkness. There were early forays in the genre, but it was with the arrival of German Expressionism that substance and style were perfectly matched.

Employing shadows and angular set designs to hint at a creeping terror, films like the psychodrama *The Cabinet of Dr. Caligari* (1920) and *Nosferatu* (1922) set a high standard for horror. The genre gained ground throughout the 1920s and hit its stride commercially with Universal Pictures' monster series, beginning with *Dracula* and *Frankenstein* in 1931. This style would remain a fixture in cinemas for another two decades, until a new kind of horror arrived with Alfred Hitchcock's *Psycho*, Michael Powell's *Peeping Tom* and Mario Bava's *Black Sunday*, all in 1960. These films marked a loosening of moral codes and censorship in Western societies, which enabled the genre to become ever-more extreme.

George A. Romero's *Night of the Living Dead* (1968) launched the popularity of the zombie film. Italy saw the rise of the Giallo film, which pushed grisly deaths to near-operatic levels of style and gore, while *The Exorcist* (1973) marked the genre's move from a fringe entertainment to the mainstream. America's most successful horror franchise, *Halloween*, has seen multiple releases to date, with Jamie Lee Curtis reviving her role in the 1978 original forty years later, in 2018. The popularity of home video saw the genre more comfortable on the small screen in the 1980s. But the next decade saw new trends emerge. Japanese and Korean horror, best exemplified by *The Ring* series, were a hit internationally. And the success of post-modern horror *Scream* (1996) and low-budget hit *The Blair Witch Project* (1999) paved the way for the genre's return to mainstream cinema, where it has remained a fixture ever since.

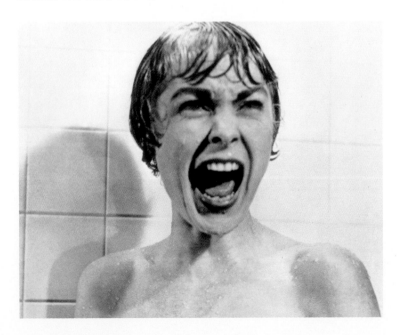

Janet Leigh in Alfred Hitchcock's *Psycho*

WHERE ON EARTH?

Can you match each of the horror movies below with the illustrated outline of the country in which it is primarily set?

1. **A Nightmare on Elm Street** (1984)
2. **Midsommar** (2019)
3. **Ring** (1998)
4. **Suspiria** (1977)
5. **The Skin I Live In** (2011)
6. **28 Days Later** (2002)

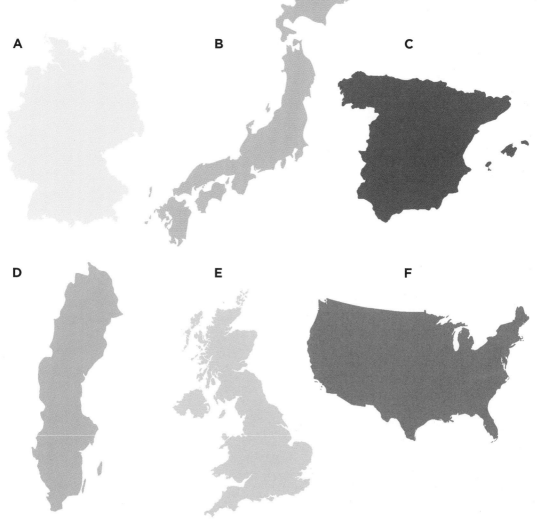

A

B

C

D

E

F

SCI-FI AND FANTASY

Science fiction and fantasy pretty much started with one man: Georges Méliès. His hundreds of inventive short films, produced between 1896 and 1912 – beautifully recreated by Martin Scorsese in his film *Hugo* (2011) – employed rudimentary editing and special effects to create fantastic worlds. Other directors would follow suit during the silent era, most notably Fritz Lang, whose *Metropolis* (1927) is an established sci-fi classic.

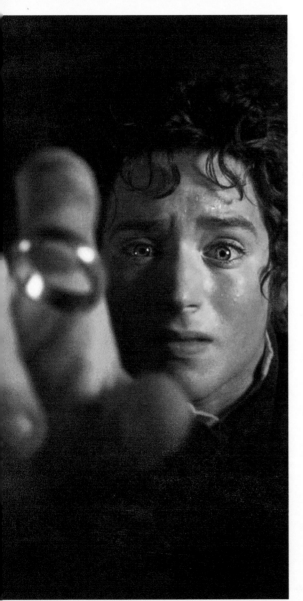

Fantasy in this era was best represented by the Douglas Fairbanks vehicle *The Thief of Bagdad* (1924). That Arabian fantasy was remade in 1940, employing a wealth of newly emerging special and visual effects and is regarded as a landmark in the genre. As was *Things to Come* (1936), a story of humanity's survival over various generations. However, the sci-fi genre really came into its own during the Cold War, when thinly veiled allegories for the fears over an imminent Russian invasion of the West populated films like *Invaders From Mars* (1953) and *Invasion of the Body Snatchers* (1956). Adaptations of Jules Verne ánd the legends of Sinbad also proved popular in this era, while serious cinema produced films like the Japanese classic *Ugetsu Monogatari* (1953), by acclaimed filmmaker Kenji Mizoguchi, and Swedish auteur Ingmar Bergman's *The Seventh Seal* (1957), in which Death appears as a character.

2001: A Space Odyssey* and *Planet of the Apes* (both 1968), along with *Star Wars* and *Close Encounters of the Third Kind* (both 1977), brought sci-fi into the modern age. The rise in visual effects technologies has made anything possible, from the creation of Middle Earth for Peter Jackson's *Lord of the Rings* (2001–03) and *The Hobbit* (2012–14) epics, to the all-too-credible disaster in space that underpins *Gravity* (2013) and the creation of entire worlds for James Cameron's *Avatar* (2009 and 2022).

Elijah Wood in Peter Jackson's *The Lord of the Rings: The Fellowship of the Ring* (2001)

PICTURE PERFECT

Each of these four images is taken from a science-fiction film in which the moon features prominently in some way. From the list of eight options beneath, can you eliminate the four outsiders and match one movie title to each image?

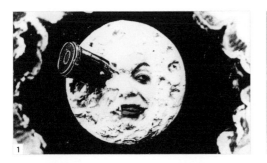

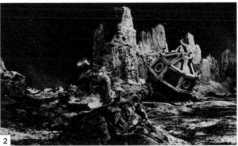

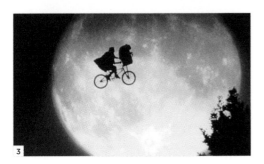

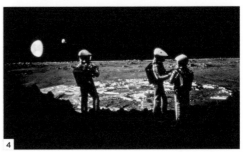

- ***2001: A Space Odyssey*** (1968)
- ***A Trip to the Moon*** (1902)
- ***Avatar*** (2009)
- ***Close Encounters of the Third Kind*** (1977)
- ***E.T. the Extra-Terrestrial*** (1982)
- ***First Men in the Moon*** (1964)
- ***Invasion of the Body Snatchers*** (1978)
- ***Planet of the Apes*** (1968)

SUPERHEROES

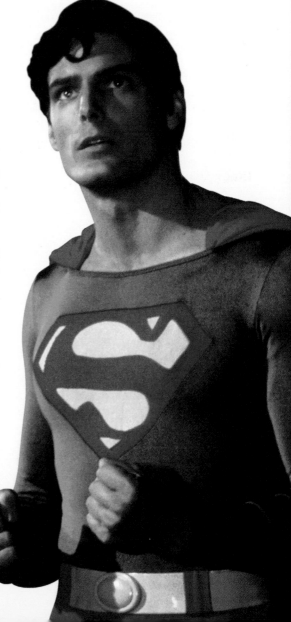

Superhero comics became popular in the 1930s and 1940s and were dominated by two worlds: DC and Marvel. It was during this era, the golden age of comics, that the adventures of Superman, Batman, Captain America and Wonder Woman began. The Flash, Green Lantern, Spider-Man, Hulk, Thor, the X-Men and others followed between the mid-1950s and 1970 – the silver age in comic book lore.

Subsequent years embraced politics and took on a darker tinge, most notably with the work of Alan Moore (*V for Vendetta*, *Watchmen*) and Frank Miller (*The Dark Knight Returns*). Cinema was slower to catch on to this trend. There were comic serials in the 1940s and 1950s, with the odd international foray in feature films, including the campy 1966 *Batman*. But the modern age of the superhero film really began with *Superman: The Movie* (1978), which made the most of nascent visual effects specialists to create a more believable superhero world. Tim Burton's *Batman* (1989) and *Batman Returns* (1992) added artistry and a dark moral register. Many films attempted to copy its blueprint in the early-to-mid-1990s, but never quite achieved its level of success.

Blade (1998), *X-Men* (2000) and the phenomenally successful *Spider-Man* (2002) cemented the popularity of screen superheroes, further bolstered by Christopher Nolan's *Dark Knight* trilogy (2005–12), the second of which, *The Dark Knight* (2008) ranks as the artistic high point of the genre. The combination of commercial success, seismic advances in visual effects and major talent both in front of and behind the camera has seen the genre dominate the global box office. Particularly following the success of *Iron Man* (2008) and the emergence of Marvel as a powerhouse filmmaking studio, creating a vast empire of interconnecting stories across both film and television. DC followed suit, but has remained behind their more storied rivals.

Christopher Reeve as Superman

SECRET IDENTITIES

The first names of ten superheroes' civilian alter egos have each been split into two and then sorted into alphabetical order below. Can you match up the pairs of name fragments to fill in each hero's alias beneath, writing one letter per underline?

BIL	BRU	CE	CLA	DIA
GA	INA	LY	NA	NATA
NY	PE	RK	RY	SEL
SHA	STE	TER	TO	VEN

Batman __ __ __ __ __

Black Widow __ __ __ __ __ __ __

Captain America __ __ __ __ __ __

Catwoman __ __ __ __ __ __

Iron Man __ __ __ __

Shazam __ __ __ __ __

Spider-Man __ __ __ __ __

Superman __ __ __ __ __

The Flame __ __ __ __

Wonder Woman __ __ __ __ __

THE MUSICAL

The coming of sound in cinema was announced with the arrival of *The Jazz Singer* (1927), a fictional musical biopic of its star, the variety entertainer Al Jolson. It was only natural that the new combination of sound and vision would revel in the possibilities of the musical and the first wave of this genre, in the 1930s, made popular by films choreographed and produced by stage impresario Busby Berkeley, were extravagant productions.

Gold Diggers of 1933, *42nd Street* and *Footlight Parade* (all 1933) featured grand ensemble productions. Later in the decade, star dance couple Fred Astaire and Ginger Rogers offered up more intimate musicals. But it was the widespread embrace of colour in the 1950s, along with the introduction of widescreen projection formats that ushered in the golden age of the genre. Most were produced by one studio: Metro-Goldwyn-Mayer (MGM). *Meet Me in St Louis* (1944), *On the Town* (1949), *An American in Paris* (1951) and *Singin' in the Rain* (1952) were just a few of its successes, where legendary writers and composers such as Rodgers and Hammerstein, Cole Porter, George and Ira Gershwin and Irving Berlin worked.

West Side Story (1961) ushered in a new, grittier kind of musical. It was followed by the hits *My Fair Lady* and *Mary Poppins* (both 1964), *The Sound of Music* (1965) and *Oliver!* (1968). But by *Cabaret* (1972), the genre's popularity was beginning to wane. Although there has been no definitive wave of musicals since, there has been the occasional hit film, from *Moulin Rouge!* (2001), *Chicago* (2002) and *Mamma Mia!* (2008) to *La La Land* (2016) and *A Star is Born* (2018).

Phyllida Lloyd's *Mamma Mia!*

MUSICAL MAESTRO

Each of the numbered songs in List 1 below was nominated for, and may have won, an Oscar for Best Original Song in the year given – or the equivalent prize in the year in question. List 2 gives the names of the movie musicals in which these songs feature, although the two lists are not in the same order.

First, match up each song to the film for which it was nominated. Then, read the letters attached to each movie title in the order of List 1 to reveal the name of a prolific composer who has won several Oscars. The film title without an initial represents a letter space.

List 1: Songs

1. 'Cheek to Cheek' (1935)

2. 'Chim Chim Cher-ee' (1964)

3. 'City of Stars' (2016)

4. 'Hopelessly Devoted to You' (1978)

5. 'Let It Go' (2013)

6. 'Let's Hear it for the Boy' (1984)

7. 'Over the Rainbow' (1939)

8. 'Remember Me' (2017)

9. 'Shallow' (2018)

10. 'The Trolley Song' (1944)

11. 'When You Wish Upon a Star' (1940)

List 2: Movies

• *A Star is Born*; K

• *Coco*; N

• *Footloose*; M

• *Frozen*

• *Grease*; N

• *La La Land*; A

• *Mary Poppins*; L

• *Meet Me in St Louis*; E

• *Pinocchio*; N

• *The Wizard of Oz*; E

• *Top Hat*; A

- -

MUSICALS TRIVIA

1. Name the musicals based on these original films and stage plays:
a. *Romeo and Juliet*
b. *Pygmalion*
c. *The Philadelphia Story*

2. Which three of these film musicals have won a Best Picture Oscar?
a. *The Broadway Melody* (1929)
b. *An American in Paris* (1951)
c. *Singin' in the Rain* (1952)
d. *The Sound of Music* (1965)
e. *The Greatest Showman* (2017)
f. *A Star is Born* (2018)

FILM NOIR

A subgenre of the thriller that appeared in American cinema in the early 1940s and remained popular until the late-1950s, film noir has its roots in hard-boiled American crime fiction of the 1930s and the stylized cinema of German Expressionism. In terms of genre, it draws on melodrama as much as the police procedural or investigative narrative. Visually, it places emphasis on stark contrasts in light to create a murky, morally ambivalent world. The line between hero and villain is often blurred. Female antagonists, referred to as femmes fatales, are common. And the film's worldview is often bleak and cynical.

The name originated with the French critic Nino Frank in 1946, six years after the release of *Stranger on the Third Floor* (1940), generally regarded as the first classic example of the genre. But it wasn't embraced as a term until the 1970s. The classic period of noir came to a close with Orson Welles' Mexican border thriller *Touch of Evil* (1958). There are numerous iconic examples, such as *The Maltese Falcon* (1941), *Double Indemnity* (1944), *Mildred Pierce* (1945), *The Big Sleep* (1946), *In a Lonely Place* (1950) and *Kiss Me Deadly* (1955). And the genre wasn't specific to the US. There was the Vienna-set *The Third Man* (1949), *Night and the City* (1950) from the UK and *Lift to the Scaffold* (1958) from France, amongst many others.

The influence of noir continued, with films referred to as neo noir. They include *Point Blank* (1967), *The Long Goodbye* (1973) and *Chinatown* (1974) as well as more recent films such as Ridley Scott's *Blade Runner* (1982), David Lynch's *Mulholland Dr.* (2001), Christopher Nolan's *Insomnia* (2002), *Knives Out* director Rian Johnson's *Brick* (2005) and Tom Ford's *Nocturnal Animals* (2016).

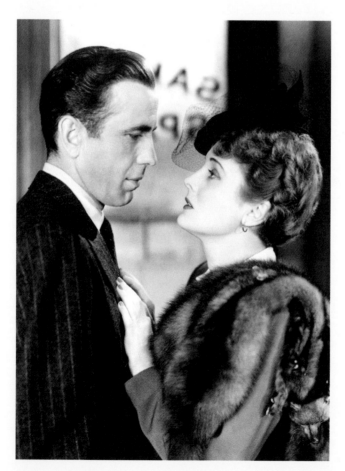

Humphrey Bogart and Mary Astor in John Huston's *The Maltese Falcon*

SHADY CHARACTERS

Shade in certain grid squares below by following the number clues to reveal the surnames of two actors known for their work in film noir. The clues provide, in reading order from left to right or top to bottom, the length of every run of consecutive shaded squares in each row and column. There must be a gap of at least one empty square between each run of shaded squares in the same row or column.

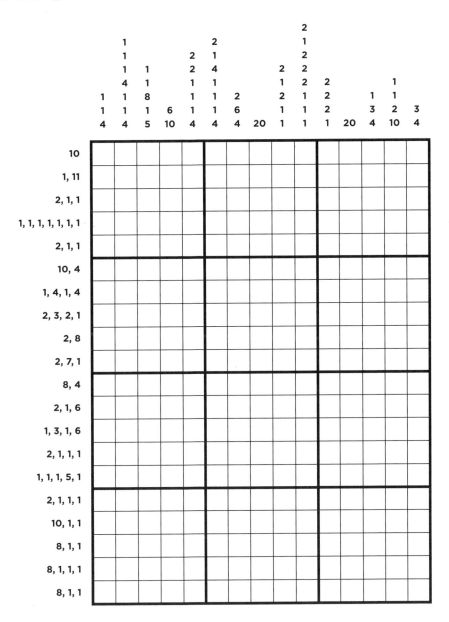

THE ROMANTIC COMEDY

A staple of commercial cinema since the arrival of synchronous sound in film, the romantic comedy is a tricky genre to master. There's humour, but it has to balance perfectly with the romantic travails of an individual or couple.

The set-up finds two characters meeting, parting ways, then finding each other again. In some cases, the characters meet other people, or their relationship remains platonic for the most part, either unwilling to acknowledge, or unaware of, where their true feelings lie. It's out of these misunderstandings, or circuitous routes to their ultimate happiness, where the comic and dramatic friction is created. The essence of the genre, going all the way back to Shakespeare's *Much Ado About Nothing*, is to show that love, in all its variations, conquers all.

The romantic comedy can unfold in any genre, or milieu, while the humour employed can run the gamut from the witty wordplay of *The Philadelphia Story* (1940), *Annie Hall* (1977), *When Harry Met Sally* (1989) and *The Big Sick* (2017) to the screwball antics of *Bringing Up Baby* (1938) and teen romance of *Pretty in Pink* (1986) and *10 Things I Hate About You* (1999), to the unashamedly romantic worlds of *Pretty Woman* (1990) and *Sleepless in Seattle* (1993).

There's mythical fantasy (*The Princess Bride*, 1987) and a more everyday kind (*Groundhog Day*, 1993), science fiction (*Eternal Sunshine of the Spotless Mind*, 2004), and films that engage with more serious issues, such as *Silver Linings Playbook* (2012), which deals with mental illness. Romantic comedy also reflects shifting changes in attitude, with *Love, Simon* (2018), *Happiest Season* (2020) and *Bros* (2022) highlighting the increasing number of LGBTQIA+ films that embrace the genre.

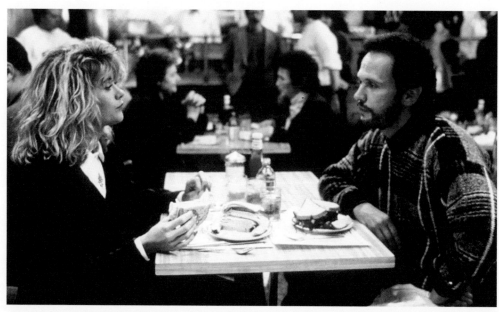

Meg Ryan and Billy Crystal in Rob Reiner's *When Harry Met Sally*

THE PERFECT MATCH

The surnames of two co-stars who appeared together in a romantic comedy have been entangled in the left-hand column below. All of the letters remain in the correct order for each name. Can you separate the names, then match each pair to a film in which they appeared together?

Co-stars

1. BMERURPRYHY

2. GHREAPBNURNT

3. HEPEPBCUKRN

4. HRAYNANKS

5. MHCUCODNSAUOGNHEY

6. MSMENIDTEHS

7. NIHCUHOLNSOTN

8. ROGBEREERTS

Films

- *As Good As It Gets* (1997)
- *Boomerang* (1992)
- *Hitch* (2005)
- *How to Lose a Guy in 10 Days* (2003)
- *Pretty Woman* (1990)
- *Roman Holiday* (1953)
- *Sleepless in Seattle* (1993)
- *The Philadelphia Story* (1940)

- -

ROMANCE TRIVIA

1. Shirley MacLaine operates a lift and Jack Lemmon has a dead-end office job.
2. Bill Murray and Andie MacDowell fall in love through repeating the same day over and over.
3. Tom Hanks and Meg Ryan remotely arrange a meeting on the top of one of the world's most iconic buildings.
4. In the answer to no. 3, the character played by Meg Ryan gets the idea of the meeting from watching which 1957 romantic drama with Cary Grant and Deborah Kerr?
5. Divorcees George Clooney and Julia Roberts forge an uneasy alliance to save their daughter from making the same mistake they did.

ICONIC LINES

A great line can be as memorable as any visually dazzling set piece in a film. Cinema is littered with dialogue that is as beloved as any film star. Some of those gems have opened a film. There's mobster Henry Hill, who begins *Goodfellas* (1990) with the admission, 'As far back as I can remember, I always wanted to be a gangster'. Or 'I believe in America', a line that captures the epic scope of *The Godfather* (1972). The first word we hear in *Citizen Kane* (1941) is 'Rosebud', a cryptic reference to the protagonist's youth that becomes the film's central mystery. These lines set the tone of what is to follow.

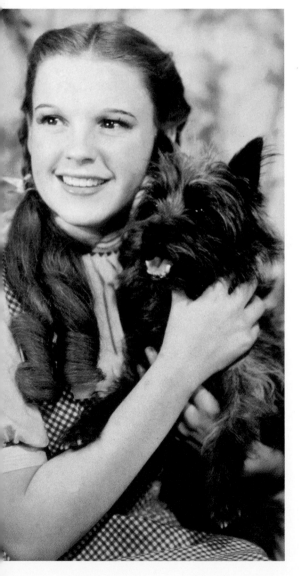

Other lines stand out in a scene. There's Dorothy telling her dog, 'Toto, I've a feeling we're not in Kansas anymore', in *The Wizard of Oz* (1939). 'May the force be with you' might have been a throwaway line from *Star Wars* (1977), but it has taken on a life of its own. And what about the response, 'I'll have what she's having', to Meg Ryan's orgasmic outburst in *When Harry Met Sally* (1989).

Some screenplays leave the best line for last. In *Casablanca*, Humphrey Bogart's Rick is at his most ironic when he tells Claude Rains' police officer, 'This is the beginning of a beautiful friendship'. *Casino Royale* (2006) smartly repurposes one of the most-used lines from the spy series, 'The name's Bond. James Bond', as a way of rebooting the franchise. *Synecdoche, New York* (2008) closes with one of the bleakest final lines, when the main protagonist is informed by his narrator, 'And, die.' But the greatest final line arguably remains one that its director, Billy Wilder, never intended to keep in the finished film. On being informed his fiancée, played by Jack Lemmon, is actually a man, Joe E. Brown's wealthy playboy nonchalantly replies, 'Well, nobody's perfect'.

Judy Garland in *The Wizard of Oz*

MISSING ICONS

Each of these famous lines is missing one crucial word.
Can you fill in each gap with the missing word, and
then match each line to the film in which it is spoken?

1. 'Here's _____ at you, kid!'

2. 'You had me at "_____".'

3. 'I'm gonna make him an _____ he can't refuse.'

4. 'You _____ to me?'

5. 'I ate his liver with some _____ beans and a nice Chianti.'

6. 'You're gonna need a bigger _____.'

7. 'Nobody puts _____ in a corner.'

8. 'I have always depended on the _____ of strangers.'

9. 'Mrs Robinson, you're trying to _____ me. Aren't you?'

10. 'A boy's best friend is his _____.'

A. *A Streetcar Named Desire* (1951)

B. *Casablanca* (1942)

C. *Dirty Dancing* (1987)

D. *Jaws* (1975)

E. *Jerry Maguire* (1996)

F. *Psycho* (1960)

G. *Taxi Driver* (1976)

H. *The Godfather* (1972)

I. *The Graduate* (1967)

J. *The Silence of the Lambs* (1991)

2

Playing the Part

Screen acting, like so many elements of the filmmaking process, has always existed in a state of permanent change. Trends in performance have seen actors' styles transform since the early days of cinema when their presence in a film would comprise little more than a brief scene. With each era, a new approach to screen performance developed, from the declamatory style of the medium's pre-sound years, when a facial expression had to communicate the essence of a scene, to the embrace of realism in a style of filmmaking that embraced a grittier portrait of the world.

Performers who attracted audiences became stars, in many cases playing variations of a role that aligned with their on-screen persona. Others profited from being known as character actors, skilled at conveying the nuances of key secondary or supporting roles to the star or lead actor. The relationship between the two was one of interdependency; a star might 'carry' a film – attract an audience – but without a talented supporting cast a film might fail and their star fade, while the supporting actor could continue working as audiences continued to flock to see their favourite stars light up the screen.

Recent technology has occasionally threatened the role of actors in popular cinema culture. And occasionally, the use of computer-generated imagery has allowed avatars to take centre stage. But for the most part, actors remain a vital element of the filmmaking process – as necessary to it as the director, producer, screenwriter and other roles that help create the worlds that unfold before our eyes.

THE EARLY YEARS

At the start of the twentieth century, as the production of short narrative films increased, there was greater demand for performers to appear in them. As certain actors became more ubiquitous, so audiences' recognition of them multiplied. The demand to see more of their favourite actors on the screen resulted in the rise of the film star.

The first screen star was French actor Max Linder. His short comedies often saw him playing a debonair and wealthy charmer who almost always found himself in compromising situations. Around the same time, Florence Lawrence became a popular presence in American films, although audiences didn't know her by name. The producer Carl Laemmle signed her to his new studio Independent Moving Pictures Company (IMP) and followed it with a public announcement that this anonymous, yet popular, screen presence had been killed by a streetcar in New York City. Lawrence was then proclaimed to be alive and

well, with the audience now knowing her name, and was due to appear in Laemmle's *The Broken Oath* (1910), which subsequently became a hit, and its lead a star.

Charles Chaplin would become the first global star, soon to be followed by Rudolph Valentino, Mary Astor, Mary Pickford, Douglas Fairbanks and many others. But the arrival of synchronous sound saw some silent actors cast by the wayside – their voices lacking the quality filmmakers were looking for. Both *Singin' in the Rain* (1952) and *The Artist* (2011) capture this radical change in filmmaking. However, the actors who embraced this new technology found their presence in a film becoming more integral to every aspect of it – from their appearance on screen to their involvement in the post-production process, through the re-recording of their voices.

Comic and silent film actor-director Max Linder

STARS AND STUDIOS

When the early stars of cinema were born, many soon found themselves tied to a movie studio on a long contract – and to a deal that could make or break them. In the crowd below, join each star to exactly one studio, represented by a film reel, using straight horizontal or vertical lines to join pairs. The ties between star and studio must never cross over those joining another star and studio, and, for the purposes of this particular puzzle, each studio is only joined to a single star.

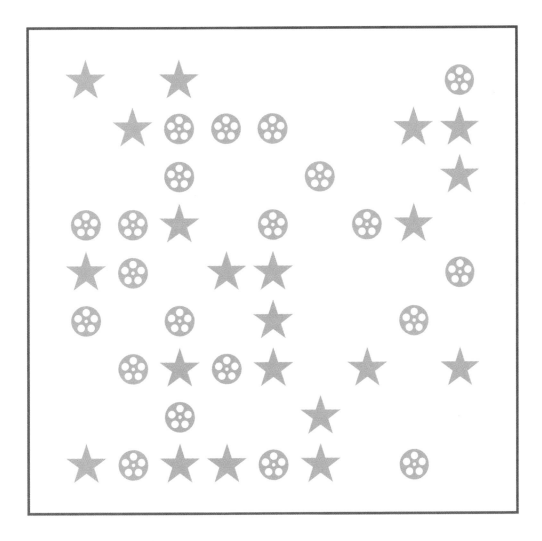

BUSTER KEATON

Of all the comedy stars of the silent era, Buster Keaton was one of the most distinctive and brilliant. An extraordinary physical performer, he was, like Charles Chaplin, a perfectionist who sought to take control of every aspect of his films.

If *Sherlock Jr.* and *The Navigator* (both 1924), and *Steamboat Bill Jr.* (1928) and *The Cameraman*, were unalloyed comic delights, *The General* (1926), an American Civil War comedy-drama is arguably his masterpiece.

Born into a vaudeville family in 1895, Keaton first appeared on stage at the age of three. Physically robust – he apparently acquired the name 'Buster' after falling unharmed down a flight of stairs as a baby – he soon proved himself a remarkable physical performer. He also noted that audiences laughed less when he smiled and so he adopted the deadpan expression that became his trademark.

When he was twenty-two, Keaton met Roscoe 'Fatty' Arbuckle, a rising star of cinema, who brought him into his troupe. His first appearance was in the 1917 film *The Butcher Boy*. Playing a customer in the country store where Arbuckle works, Keaton shone. Within a few years, he had his own production unit, first producing slapstick shorts, then moving on to features with *The Saphead* (1920). For five years, spanning *Our Hospitality* (1923) to *The Cameraman* (1928), Keaton starred in and co-directed a series of wildly inventive comedies.

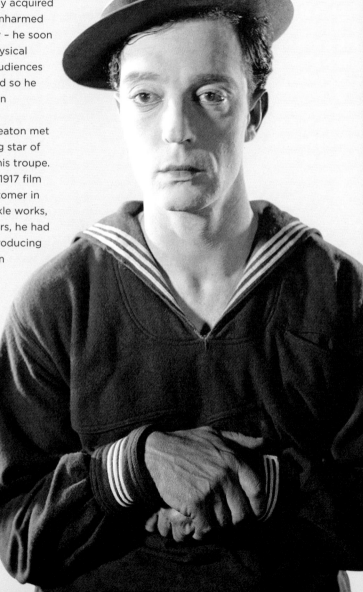

Buster Keaton in
The Navigator

TRAINING DAY

The General (1926) features several stunt scenes involving a vintage locomotive, all of which had to be very carefully timed and executed while filming to avoid injury to the cast and crew.

Similarly, can you carefully plan out the route of a train track in the grid below, by following the given number clues to place the track pieces correctly? To do so, draw track pieces in some squares to complete a track that travels all the way from its entrance in the leftmost column to its exit in the bottom row. It can't otherwise exit the grid, and nor can it cross itself. Numbers outside the grid reveal the number of track pieces in each row and column, and every track piece must either go straight or turn a right-angled corner. Some pieces are already given.

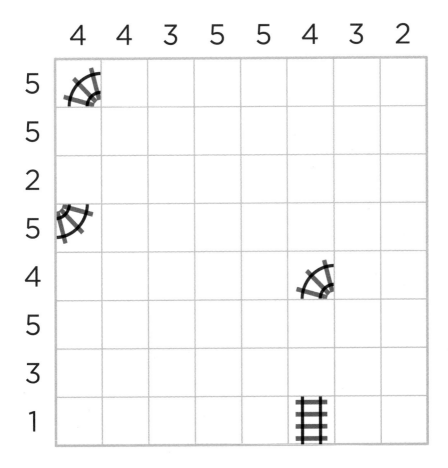

THE GOLDEN AGE OF HOLLYWOOD

Any discussion of Hollywood glamour will invariably lead to what has been called the Golden Age, when studios ruled, stars shone and Hollywood produced a body of work that fizzled with sophistication and élan.

Unfolding between the late pre-sound era and the 1960s, this period cemented a style of filmmaking that has remained dominant in commercial cinema – where editing is seamless; shots and scenes move fluidly from one moment to the next; narratives are linear, creating the illusion of a logical, functioning world; and actors' performances bolster the 'reality' of that world.

Hollywood during this era was a filmmaking factory, producing big-budget spectaculars and low-budget fare, all in the name of entertainment. Some films tackled weighty themes or pushed the envelope of what was permissible, but all within the boundaries of a filmmaking practice whose efficiency and

profitability was paramount. It was an era in which stars dominated the screen, but their lives and career choices were decided by studio heads. The glamour and dazzle that audiences saw was part of a well-orchestrated campaign to win at the box office. And if a star's shine ever tarnished, they soon became yesterday's news.

This was an era when genre cinema dominated, with trends dictated by a combination of studio decisions and audiences' tastes. A film's success often depended on giving audiences a little of what they enjoyed, while ensuring there was always something unique to differentiate what they had previously seen. Likewise, stars balanced the appeal that made them a success with performances that were fresh enough to ensure that audiences would always want to come back for more.

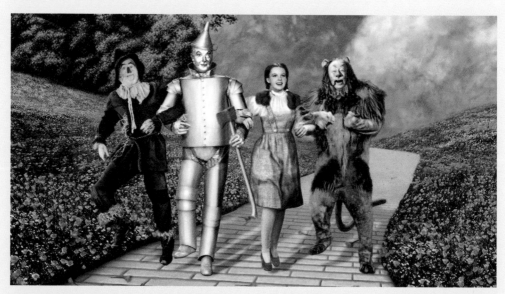

Victor Fleming's *The Wizard of Oz* (1939)

GOLDEN TICKETS

Each of the following films from Hollywood's Golden Age has had its name jumbled. Can you unscramble them all to reveal the correct movie titles? Punctuation and spaces have been removed, and then some new spaces and sometimes also punctuation inserted. One star per movie is provided as a clue.

1. **CAB AS A CLAN** (10) (1942) – Humphrey Bogart

2. **ITSY GLITCH** (4, 6) (1931) – Charlie Chaplin

3. **PENITENT HOPING HEAD** (2, 8, 3, 5) (1934) – Clark Gable

4. **THE WOW HIT ENDING** (4, 4, 3, 4) (1939) – Olivia de Havilland

5. **SHY, RIGID FLAIR** (3, 4, 6) (1940) – Cary Grant

6. **SHINIER GIANT INN** (6, 2, 3, 4) (1952) – Debbie Reynolds

7. **SEMI-TOOTHLIKE** (4, 4, 2, 3) (1959) – Marilyn Monroe

8. **THAT FAT CHOICE** (2, 5, 1, 5) (1955) – Grace Kelly

9. **FAIREST, DOLEFUL WIN** (3, 1, 9, 4) (1946) – James Stewart

10. **KINETIC NAZE** (7, 4) (1941) – Orson Welles

11. **BRAINY STAFF TAKES FAT** (9, 2, 8) (1961) – Audrey Hepburn

12. **LOVE TABLEAU** (3, 5, 3) (1950) – Bette Davis

- -

GOLDEN AGE TRIVIA

1. For decades, this epic 1939 US Civil War drama, based on the eponymous novel by Margaret Mitchell, was the greatest box office hit of all time. Name the film.

2. Which two feuding actresses, known for their antipathy towards each other, played bickering sisters in the 1962 drama *Whatever Happened to Baby Jane?*

3. His 1924 debut *White Man* (1924) is now considered lost. His last film was *The Misfits* (1961), opposite Marilyn Monroe. Who was he?

CARY GRANT AND KATHARINE HEPBURN

Two of classical Hollywood's most versatile stars, Cary Grant and Katharine Hepburn combined star power and no small amount of skill as actors to dominate the box office for decades. However, their journey to the top was not entirely smooth.

English-born Grant moved from vaudeville theatre to film in the early 1930s. His most notable screen outings at the start of his career were opposite comedienne Mae West. A few box-office failures threatened his career, but then he was cast opposite Katharine Hepburn in *Sylvia Scarlett* (1935). Born into a progressive liberal family on the East Coast of the United States, Hepburn's success on Broadway led her to Hollywood. Her sparky persona worked well against Grant's and earned the praise of critics. Audiences were initially less enamoured – their first few films together, including the classic screwball comedy *Bringing Up Baby* (1938) failed to light up the box office. But their

fortunes changed with their 1940 collaboration, *The Philadelphia Story*. A huge success, it cemented their star status.

Grant's best work was with Alfred Hitchcock and Howard Hawks. With both, he explored characters whose complexity was barely concealed by his suave, seemingly untroubled facade. Hitchcock's *Notorious* (1946) and *North by Northwest* (1959), and Hawks' *Only Angels Have Wings* (1939) and *His Girl Friday* (1940) saw him at his finest. Hepburn would gradually become one of the most respected actors in Hollywood history, winning four Best Actress Academy Awards. Unlike Grant, who retired at the height of his fame in 1966, Hepburn would enjoy a career that spanned more than sixty years. In all her films, she radiated intelligence while conveying a frailty that made her, like Grant, a compelling screen presence.

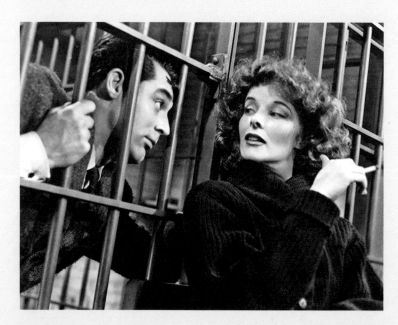

Cary Grant and Katharine Hepburn in *Bringing Up Baby*

PIECE BY PIECE

In *Bringing Up Baby* (1938), Grant's character attemps to piece together the skeleton of a Brontosaurus after years of painstaking work. One small piece, however, is missing, and is preventing him from completing the whole structure. Test your own ability to reassemble small pieces by joining up the fragments below to reveal the full names of some of Hepburn and Grant's co-stars. Each name has been split into three or more fragments, but one name is missing a piece. Can you identify all the co-stars, and work out what the missing piece should look like? Spaces between first and last names have been removed.

AN ART CERT ESS

EWE GART HUM INGR

JAM JOA MA NE

NFON PHRE RACY RGM

SPEN ST TAI TEW

YBO

CHILD ACTORS

Child stars existed as early as the first years of the feature film. Not all graduated successfully to adult stardom. Jackie Coogan, arguably the world's first major child star, thanks to his role opposite Charles Chaplin in his feature debut *The Kid* (1921), may not have had the most illustrious adult career – he's best known for playing Uncle Fester in the TV series *The Addams Family* – but his lawsuit against his mother and stepfather for squandering the fortune he earned when he was young, which became known as the 'Coogan Bill', would help preserve the earnings of future child stars in the United States.

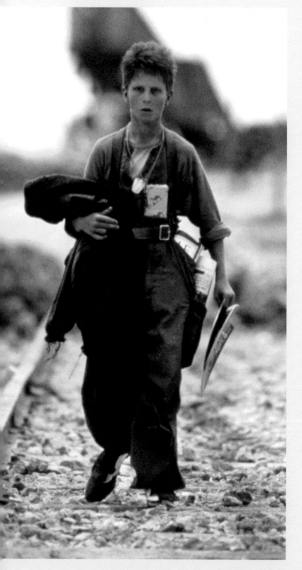

Mickey Rooney and Judy Garland both enjoyed continued success after achieving early stardom in the 1930s. But the cost of such fame, particularly for Garland, took a heavy toll. Years later, Drew Barrymore experienced a similar fate, only to reinvigorate her career as a producer-star. Elizabeth Taylor arguably fared better in the 1940s, successfully becoming Hollywood royalty when she was young – a status she maintained throughout her working life.

Kurt Russell started his career as an all-American boy-next-door type in 1960s Disney movies only to excel as an action star, and, as a child, Jodie Foster balanced kid-themed films like *Bugsy Malone* (1976) with more adult-themed films such as *Taxi Driver* (1976), before becoming a two-time Oscar winner. Christian Bale broke out with his headlining performance in Steven Spielberg's *Empire of the Sun* (1987) and continued to tread a path of serious roles, with the occasional big budget spectacular. It is a similar route taken by Kirsten Dunst, Scarlett Johansson, Kristen Stewart, Dakota and Elle Fanning, and Ryan Gosling, who all started their careers as young talents with the hope of continuing their success into adulthood.

Christian Bale in Steven Spielberg's
Empire of the Sun

FIRST CLASS

Each of the disguised names below is that of an actor who appeared at a young age in the film they are paired with. Each actor's name, however, has had its letters shifted forwards through the alphabet by a consistent amount, equal to their age during the film's production. Can you work out which Hollywood stars appeared in these movies in their early careers, and their age when principal photography began?

For example, Christian Bale was 13 during the filming of *Empire of the Sun*, so his name shows as PUEVFGVNA ONYR, where C moves 13 letters forward through the alphabet to become P; H becomes U; and so on, wrapping around the end of the alphabet back to A as needed, so R becomes E.

ZMFMXUQ BADFYMZ – *Léon: The Professional* (1994)

KYLD IHYYFTVYL – *E.T. the Extra-Terrestrial* (1982)

SQZABMV LCVAB – *The Bonfire of the Vanities* (1990)

FPNEYRGG WBUNAFFBA – *The Horse Whisperer* (1998)

TIWPC WPLZT – *Explorers* (1985)

YTNSZWLD SZFWE – *About a Boy* (2002)

JKRPJRU KANBURW – *Little Miss Sunshine* (2006)

RFWF BNQXTS – *Mrs Doubtfire* (1993)

IT'S ALL IN THE METHOD

The influence of Russian theatre practitioner Konstantin Stanislavski began to be felt in cinema in the years after the Second World War. It would challenge the dominance of the classical Hollywood style, creating a kind of performance that exploded with raw energy. Although regarded as realistic at the time, it is no less an artifice than any other acting style. But in the hands of the most accomplished actors, it possessed a power that helped transform certain kinds of cinema.

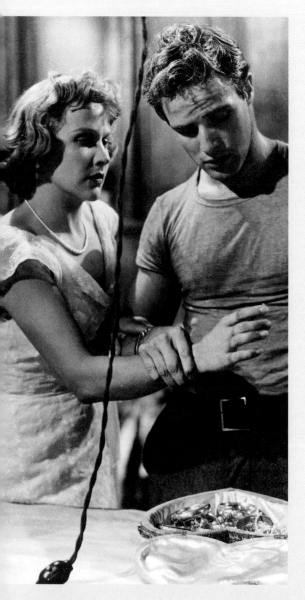

Stanislavski's ideas were put into action in the United States by three influential teachers: Lee Strasberg, Stella Adler and Sanford Meisner. Each explored, respectively, the psychological, sociological and behavioural aspects of performance. Two of the earliest exponents of this style were Marlon Brando and James Dean. Brando's portrayal of Stanley Kowalski in *A Streetcar Named Desire* (1951) was a brazen display of unfettered sexuality, while in *Rebel Without a Cause* (1955) Dean offered up a portrayal of youth that had previously been absent in cinema. Dean had been a student of Strasberg's, while Brando was one of Adler's most famous acolytes. Other actors from that era who embraced the method style and helped usher in a more emotionally naked style of acting included Marilyn Monroe, Paul Newman and Montgomery Clift. The following decades saw the number of successful method actors increase, a new generation bringing even more extreme emotions to the screen. They reflected a new generation of filmmakers who sought a new kind of cinema that perfectly suited the talents of actors like Al Pacino, Robert De Niro, Jack Nicholson, Daniel Day-Lewis, Hilary Swank and Christian Bale.

Kim Hunter and Marlon Brando in Elia Kazan's *A Streetcar Named Desire*

BLURRING THE LINES

On each line below, the name of a leading actor associated with method acting has become entangled with the name of a character they have famously played – blurring the lines between character and actor.

Can you first of all separate each actor from their character, and then secondly assign each pair to a film beneath? Spaces and punctuation for the actors and their characters have been removed.

1. BDIALLNTIHEELBDUATYCLHEWEISR

2. LIDINADNAECKHERAITSOTINE

3. DBUESNTJAIMNINBHROAFDFDMOCANK

4. JGROEGEOBRYRAPDLECEKY

5. EJIALNEENETFYOLNEDRA

6. MSTARANLOLENYKOBWARALNSDKOI

7. LMOARRELYELIINMOLNEREOE

8. RJAOBKERETLADMEOTNTIRAO

A. *A Streetcar Named Desire* (1951)

B. *Gangs of New York* (2002)

C. *Gentlemen Prefer Blondes* (1953)

D. *Play It Again, Sam* (1972)

E. *Raging Bull* (1980)

F. *Roman Holiday* (1953)

G. *Sunday in New York* (1963)

H. *The Graduate* (1967)

STARS IN EUROPE

Hollywood did not have a monopoly on stars. From Max Linder, the first star of cinema, all cinema-producing countries on the continent sought out and promoted their own roster of screen icons. Some enjoyed fame only within the boundaries of their own country while others' fame extended far beyond it.

In the years after the Second World War, as cinema was undergoing radical change thanks to new generations of filmmakers keen to play with the medium, new stars emerged. The Italian film renaissance that began with neorealism – a movement that focused on the lives of the country's poor and was mostly shot on location – and progressed with the films of Federico Fellini and Michelangelo Antonioni, saw a wealth of new talent emerge, such as Marcello Mastroianni and Monica Vitti. In French cinema, Brigitte Bardot, Jeanne Moreau, Simone Signoret, Jean-Paul Belmondo and Catherine Deneuve became icons. And thanks to his work with Ingmar Bergman, Swedish actor Max von Sydow became a ubiquitous presence across European cinema.

Today, there is no shortage of European stars claiming prestigious parts in Hollywood movies as well as domestic productions, with actors from Juliette Binoche to Vincent Cassel and Javier Bardem in lead roles. Memorable performances include Danish Mads Mikkelson as Le Chiffre in *Casino Royale* (2006), Austrian-German Christoph Waltz as Hans Landa in Tarantino's *Inglourious Basterds* (2009) and French Marion Cotillard, playing opposite Leonardo DiCaprio in *Inception* (2010).

Mads Mikkelson

LEADING LADIES

Fit the capitalized surnames of these leading ladies of European cinema into the grid, writing one letter per box so that each name can be read from left to right or top to bottom. When complete, the letters in the shaded boxes can be rearranged to spell out the surname of a final star. Who is it?

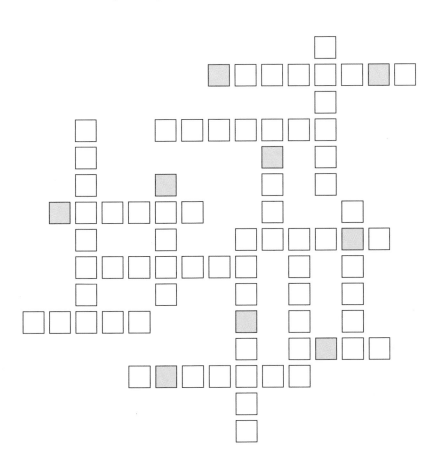

4 letters

Penelope CRUZ

5 letters

Greta GARBO

Sophia LOREN

Carmen MAURA

6 letters

Brigitte BARDOT

Cecile de FRANCE

Jeanne MOREAU

Noomi RAPACE

Audrey TAUTOU

7 letters

Ingrid BERGMAN

Juliette BINOCHE

Catherine DENEUVE

8 letters

Monica BELLUCCI

Marlene DIETRICH

Alicia VIKANDER

JEANNE MOREAU

The quintessential French film star, Jeanne Moreau is identified with a key movement in European cinema, but also forged a successful screen career beyond it. She combined the trappings of an international film star with a body of work that cemented her reputation as one of cinema's most accomplished actors.

Malle cast her opposite Brigitte Bardot in the revolutionary adventure *Viva Maria!* Moreau's screen career eventually spanned sixty-five years and her status as one of France's most iconic screen presences remained undiminished for all of it.

A leading actor with the acclaimed French theatre company Comédie-Française in her early twenties, Moreau's first decade in film comprised small roles. This changed when she earned praise for her performance as a deceitful wife planning her husband's murder with her lover in Louis Malle's thriller *Lift to the Scaffold* (1958). She cemented that success later that year in Malle's subsequent *The Lovers*, which captured the shifting mores of Western society. But it was her performance as a woman with two lovers in François Truffaut's *Jules et Jim* (1962) that fully established her with international audiences. A key film in the influential French New Wave movement, Moreau's performance would forever associate her with this era.

Like many European stars of the era, Moreau combined roles in French films with appearances in work by international directors. A year before *Jules et Jim*, she worked with Michelangelo Antonioni on *La Notte* (1961), a coruscating portrait of twenty-four hours in the life of a married couple whose relationship has reached a dead end. She appeared as the lead in Spanish satirist Luis Buñuel's *Diary of a Chambermaid* (1964) and opposite Burt Lancaster in Hollywood director John Frankenheimer's Second World War drama, *The Train* (1964). Orson Welles cast her in his take on Shakespeare, *Chimes at Midnight* (1965), while in the same year

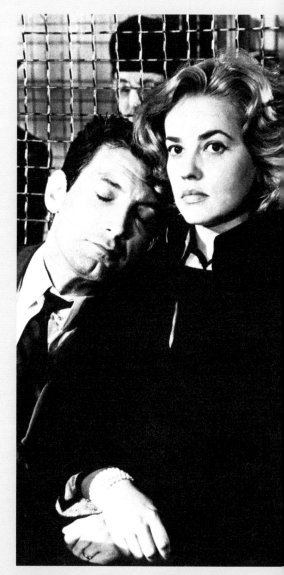

Jeanne Moreau in Louis Malle's *Lift to the Scaffold*

THE LOVE TRIANGLE

Jules et Jim (1962) stars Jeanne Moreau at the centre of a complex love triangle spanning several years, with tragic results. Can you find your way through your own maze of 'love triangles' below, starting at the 'IN' arrow and following a path through the triangular corridors all the way to the 'OUT' arrow?

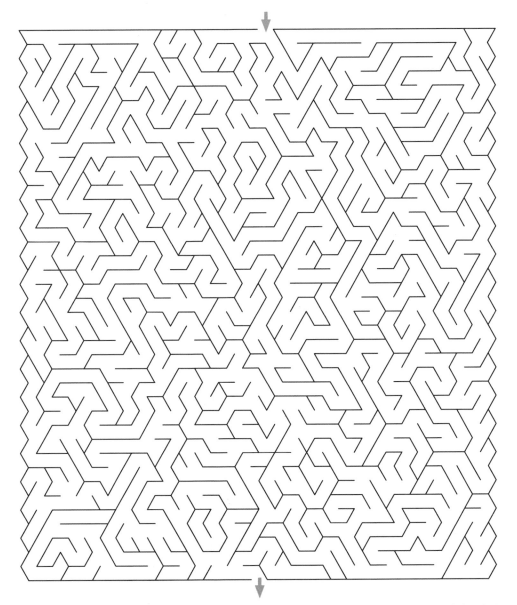

BOLLYWOOD

The Hindi strand of Indian cinema, Bollywood represents the vast film industry located in and around Mumbai. A portmanteau of Bombay (the former name of the city) and Hollywood, like its US counterpart it is an industry that developed in the early part of the twentieth century and now ranks as one of the most successful cinemas in the world. And like its US counterpart, it is structured around studios and has a star system that promotes established names and up-and-coming talent.

Key elements of the most significant Bollywood films were the fusion of music and drama. This took on a new style in the 1970s, known as the 'Masala' film, which blended different genres with musical numbers. It is this kind of filmmaking that has come to dominate international perceptions of what Bollywood cinema is: colourful, extravagant films that combine suspense, humour, romance and high drama, located in milieus that may draw upon a variety of other genres, from the western to the spy film. Developed by screenwriters Salim Khan and Javed Akhtar, this style of cinema was accompanied by the rise of a new generation of stars, most notably Amitabh Bachchan. In films like *Zanjeer* (1973), *Deewaar* and *Sholay* (both 1975), he played bad-boy characters. But over time he came to be regarded as screen royalty and one of the most respected actors in Indian cinema. Female stars from the era included Hema Malini, Jaya Bachchan, Rakhee Gulzar and Shabana Azmi. And in the years since, actors like Shah Rukh Khan, Aishwarya Rai, Kareena Kapoor and Aamir Khan have dominated this vibrant and exciting cinema.

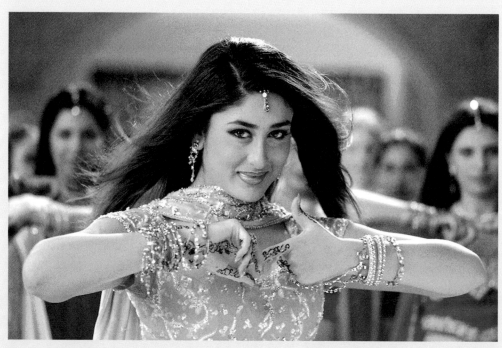

Kareena Kapoor in *Sometimes Happiness, Sometimes Sadness* (2001)

LEADING LEGEND

Place one of A, E, H, I, L, M, N, R or S into each empty square so that no letter repeats in any row, column or bold-lined 3 × 3 box. When complete, the name of a Bollywood actress will be revealed in the shaded squares, reading down the diagonal from top to bottom. Active in the 1960s, this Bollywood star became known as a 'daring diva' for the relatively feminist roles she undertook.

		S	I		L	H		
		I				L		
E	N		R		S		A	I
R		M				S		E
N		E				A		H
A	I		S		R		L	M
		N				I		
		R	H		N	E		

ASIAN STARS

Asian cinema can be divided between a vast output of commercial fare and more artistically inclined releases. Unlike Western cinema, where there may be a gulf between commercial stars and their arthouse counterparts, the greatest actors in Asian cinema have often traversed both worlds.

From an international perspective, one of the earliest Asian stars was Toshiro Mifune, who appeared in seventeen films directed by Akira Kurosawa and would also star in Western productions, such as the Second World War adventure *Hell in the Pacific* (1968), opposite Lee Marvin. But it was the arrival of martial arts films in the 1960s and 1970s that saw an explosion in Asian films around the world. The major star was Bruce Lee, followed by Jackie Chan. But there were also female stars, such as Cheng Pei-pei, beloved of cult wuxia (period martial arts) director King Hu and who would play a pivotal role as the villain in *Crouching Tiger, Hidden Dragon* (2000).

That film also starred Michelle Yeoh and Chow Yun-Fat, whose stars would rise from the 1980s. Chow, in particular, profited from his work with 'bullet ballet' action director John Woo, in films such as *The Killer* (1989) and *Hard Boiled* (1992), while Yeoh went on to deliver a multi-award-winning performance in *Everything Everywhere All at Once* (2022).

The emergence of the Fifth Generation of Chinese cinema in the 1980s saw the rising star of Gong Li. She started out in the films of Zhang Yimou and Chen Kaige, such as *Red Sorghum* (1987) and *Farewell My Concubine* (1993), but her appeal broadened and like many Asian actors whose appeal became international, she was as comfortable in arthouse films like *2046* (2004) as she was in the US thriller *Miami Vice* (2006).

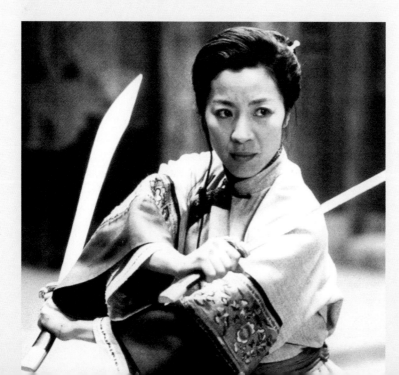

Michelle Yeoh in Ang Lee's *Crouching Tiger, Hidden Dragon*

JACKIE CHAN

Each of the films clued below stars Jackie Chan, but each movie's title has been listed with a newly translated English name. Can you paraphrase each of the lines below to work out the true English-language title of each movie?

Write in the correct name beneath each title, placing one letter per underline.

Rush Hour, for example, might have been clued as *High Traffic for 60 Minutes*.

1. *Intoxicated Expert* (1978)

__ __ __ __ __ __ __ __ __ __ __

2. *The Unafraid Dog-Like African Mammal* (1979)

__ __ __ __ __ __ __ __ __ __ __ __ __ __ __ __

3. *The Juvenile Virtuoso* (1980)

__ __ __ __ __ __ __ __ __ __ __ __ __ __ __ __

4. *Victors and Transgressors* (1983)

__ __ __ __ __ __ __ __ __ __ __ __ __ __ __ __ __

5. *Sparkle, Sparkle, Fortunate Celestial Objects* (1985)

__ __ __ __ __ __ __, __ __ __ __ __ __ __ __ __ __ __ __ __ __ __ __ __ __

6. *Atoll of Flames* (1990)

__ __ __ __ __ __ __ __ __ __ __ __

7. *Lawbreaking Tale* (1993)

__ __ __ __ __ __ __ __ __ __ __

8. *Definitive Unintentional Agent* (2001)

__ __ __ __ __ __ __ __ __ __ __ __ __ __ __ __

TONY LEUNG

Few actors have so successfully balanced a career in mainstream cinema while working with some of the most important arthouse directors as Tony Leung.

He started out in television, his good looks securing his status as a natural lead actor. But it was his performance in director Hou Hsiao-hsien's 1989 drama *A City of Sadness* that saw him break through internationally. From there, he began working with filmmaker Wong Kar-wai on artful films such as *Days of Being Wild* (1990), *Chungking Express* (1994) and *Happy Together* (1997), culminating in his appearance opposite Maggie Cheung in the rapturous relationship drama *In the Mood for Love* (2000). His performance earned him a Best Actor award at the Cannes Film Festival and is now regarded as one of the greatest films ever made. He also recorded songs for that film, a hint to international audiences of his success in the 1990s as a Cantopop star, which he eventually gave up to focus on acting.

In addition to these roles, and working with Ang Lee on the Venice International Film Festival-winning erotic thriller *Lust, Caution* (2007), Leung successfully cultivated a mainstream screen persona, starring in John Woo's action crime epics *Bullet in the Head* (1990) and *Hard Boiled* (1992), appearing in the balletic martial arts dramas *Hero* (2002) and *The Grandmaster* (2013), the crime drama *Infernal Affairs* (2002), adapted by Martin Scorsese in 2006, and eventually making his way into the world of Marvel, playing the villain and titular hero's father in *Shang-Chi* and the *Legend of the Ten Rings* (2021).

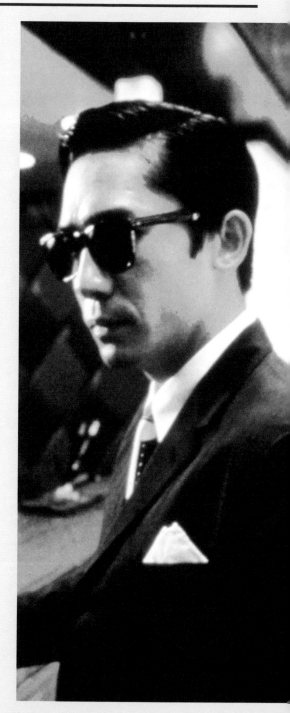

Tony Leung in *In The Mood for Love*

Can you delete one letter from each pair below to reveal the name of a city associated with the given film, all of which feature Tony Leung?

1. **NB AU SE NL OU TS GA IO NR ER YS**
Happy Together (1997)

2. **VT AO EI PN GE IA**
A City of Sadness (1989)

3. **PH OK NU NG BK OA HN TG**
Hard Boiled (1992)

4. **LS HK EA IN GS HT OA NI**
Lust, Caution (2007)

5. **SH TO RC OH IM NM IO AN GH TC IO TS YN**
Cyclo (1995)

6. **GM OA ND WI LP LA**
Days of Being Wild (1990)

- -

TONY LEUNG TRIVIA

1. Leung played one of the protagonists in the 2002 cop drama *Infernal Affairs*. What was the title of Martin Scorsese's Oscar-winning 2006 remake?

2. What role did Leung play in the steamy 2007 Venice Film Festival winner, *Lust, Caution*?

3. Leung is a regular collaborator with filmmaker Wong Kar-wai. But which one of these films did he not star in: *The Grandmaster* (2013), *2046* (2004) or *Fallen Angels* (1995)?

HOLLYWOOD ACTION STARS

From the pioneering *The Great Train Robbery* (1903), whose advances in the use of editing created thrilling chase sequences, the action film has been a mainstay of popular cinema. Countless action stars populated the medium during its silent years, from the knockabout antic of comedy actors to the derring-do of swashbuckling romantic leads. Westerns and gangster films offered audiences a plentiful supply of action stars during Hollywood's Golden Age between the 1930s and late 1950s.

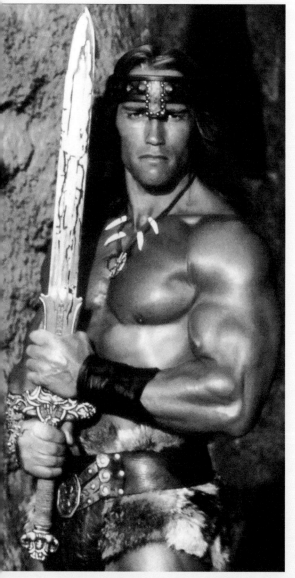

James Bond ushered in a new kind of action star in the 1960s and spawned numerous imitators. But it was the emergence of two unlikely stars in the late 1970s and early 1980s that saw the action hero rise to a new level. Sylvester Stallone, through his characters Rocky Balboa and then John Rambo, and Arnold Schwarzenegger, with Conan, the Terminator and a run of brawny heroes, redefined the action star completely. Mel Gibson and Bruce Willis followed on with a more 'ordinary Joe' take on the action hero. Keanu Reeves would embrace a similar persona with Jack Traven in *Speed* (1994), before taking the hero image to mythic levels with Neo in the *Matrix* series and John Wick in the hitman's eponymous adventures.

There were also female action stars. Ever since Joan Crawford and Barbara Stanwyck took charge in the westerns *Johnny Guitar* (1954) and *Forty Guns* (1957), women have gradually increased their role in the action genre, from Sigourney Weaver and Linda Hamilton in the *Alien* and *Terminator* franchises to Geena Davis in *The Long Kiss Goodnight* (1996), Jennifer Lawrence in *The Hunger Games* trilogy and Charlize Theron in *Atomic Blonde* (2017). The Marvel universe has followed suit, placing increasing emphasis on the importance of its female action characters.

Arnold Schwarzenegger in John Milius' *Conan the Barbarian* (1982)

RUNNING THE NUMBERS

Reveal the answers to each of the following clues by solving the brain chains. For each chain, start with the number on the left and perform each of the mathematical operations in turn as you follow the arrows. Try to do this in your head, without making any written notes. In the final, empty box, write in the resulting number to reveal the solution to the clue.

1. The year the Terminator is sent back from in *The Terminator* (1984)

100	x 10	+ 10	x 2	+ 9	

2. Name of the NASA spaceship hijacked in *You Only Live Twice*: Jupiter _____ (1967)

12	x 12	+ 16	x 0.5	÷ 5	

3. Number of crew members on the *Nostromo* at the start of *Alien* (1979)

36	x 5	- 120	+ 3	÷ 9	

4. The number of dollars in millions set as a final bounty in *John Wick* (2014)

21	x 3	+ 1	÷ 8	- 4	

TOM CRUISE

For the last forty years, US actor Tom Cruise has been strutting his star persona on screen. He started out as part of what became known as the Brat Pack, a new generation of young US actors in ensemble dramas. But his star was to become the brightest thanks to a series of hit films that defined an era.

Cruise, born Thomas Cruise Mapother IV on 3 July 1962, first attracted attention by playing a villain – one of the few in his career – alongside Sean Penn and Timothy Hutton in the military academy drama *Taps* (1981). But it was his turn as an entrepreneurial student in *Risky Business* (1983) that saw his career take off. Three years later, he played LT Pete 'Maverick' Mitchell, an ace US Navy pilot, in *Top Gun* and his star status was cemented.

Much of Cruise's appeal lies in his attraction to outsider characters who come good. Often loners who learn to accept the importance of working with others – from his *Top Gun* character, Charlie Babbitt in *Rain Man* (1988) and Ethan Hunt in the *Mission Impossible* series, to John Anderton in *Minority Report* (2002), and William Cage in *Edge of Tomorrow* (2014) – his persona is a modern take on the classical Hollywood hero. But Cruise has also been willing to push himself, with challenging roles in *The Color of Money* (1986), *Born on*

the *Fourth of July* (1989), *Magnolia* (1999) and *American Made* (2017). And in an age when visual effects and superheroes dominate the multiplexes, the success of *Top Gun: Maverick* (2022) showed that Cruise may be the last example of the good old-fashioned movie star.

STILL LIFE: TOM CRUISE MOVIES

Each of the stills below is taken from a movie in which Tom Cruise plays the leading role. Can you identify each movie, and match it to the first name of the character played by Cruise in that movie? These names are given, but their letters have been jumbled up to make it trickier.

BARNI **NAILED** **TEEP**

ERRJY **RICHALE** **THANE**

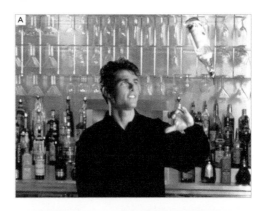

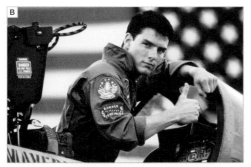

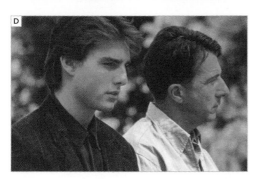

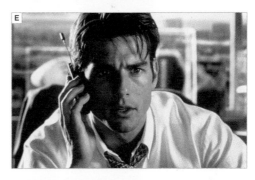

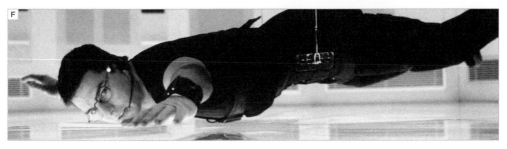

JULIA ROBERTS

A star whose career has embraced roles that display her dexterity and range as an actor, Julia Roberts became famous at a fairly young age thanks to a blockbuster hit. She then balanced audience-pleasing mainstream roles that bolstered her star persona with more challenging fare that earned her respect, acclaim and accolades.

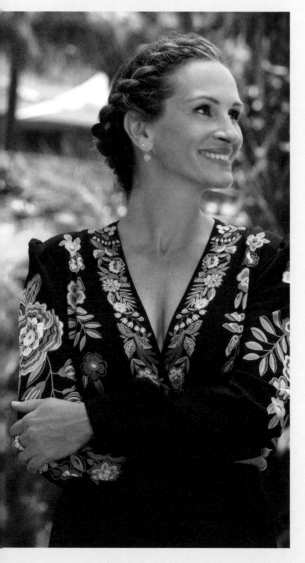

Roberts was twenty-two when *Pretty Woman* (1990) was released. She had previously starred in just five films. *Satisfaction* and *Mystic Pizza* (both 1988) made the most of her screen charisma, but it was her central role in the female-led ensemble drama *Steel Magnolias* (1989) that highlighted her skill as an actor. Then *Pretty Woman* changed everything – her combination of innocence, charm, chutzpah and wittiness in playing Vivian Ward transformed her into one of the faces of the 1990s. A decade later, after appearing in films such as *Flatliners* (1990), *My Best Friend's Wedding* (1997), *Stepmom* (1998) and *Notting Hill* (1999), she won an Academy Award and BAFTA for her nuanced portrayal of a real-life legal investigator in *Erin Brockovich* (2000).

Appearances in mainstream hits such as *The Mexican* (2001), *Mona Lisa Smile* (2003), *Eat Pray Love* (2010), *Wonder* (2017) and *Ticket to Paradise* (2022) have been interspersed with more daring performances in *Closer* (2004), *August, Osage County* (2013), *Homecoming* (2018) and *Gaslit* (2022). In each, Roberts succeeds in balancing her natural, easy-going screen persona with layered characterization that gives the roles she plays greater depth. It's an impressive balancing act that has made her one of Hollywood's most successful stars.

THE OTHER HALVES

For each film listed below, one of Julia Roberts's co-stars is given – but their surname has been deleted. First, fill in the missing surnames by writing one letter per underline, then find the surnames in the word-search grid. One name will be missing, however – which one, and can you say why that co-star might not be 'seen' on this occasion?

Movie	Co-star
1. *Closer* (2004)	**Jude** _ _ _
2. *Eat, Pray, Love* (2010)	**Javier** _ _ _ _ _
3. *Hook* (1991)	**Robin** _ _ _ _ _ _ _ _
4. *Notting Hill* (1999)	**Hugh** _ _ _ _ _ _
5. *Pretty Woman* (1990)	**Richard** _ _ _ _
6. *Something to Talk About* (1995)	**Dennis** _ _ _ _ _ _
7. *The Ant Bully* (2006)	**Nicolas** _ _ _ _
8. *The Mexican* (2001)	**Brad** _ _ _ _
9. *The Pelican Brief* (1993)	**Denzel** _ _ _ _ _ _ _ _ _ _
10. *Ticket to Paradise* (2022)	**George** _ _ _ _ _ _ _
11. *Wonder* (2017)	**Owen** _ _ _ _ _ _

```
F  G  V  E  R  E  G  F  F  C  L  W  N
A  M  M  I  S  K  K  K  E  C  I  A  F
P  L  M  E  D  R  A  B  W  L  U  N  W
G  M  U  Z  B  L  E  I  L  R  O  F  T
Y  F  U  F  F  U  L  I  F  T  B  W  Z
E  H  G  U  I  S  A  L  G  E  H  Z  G
N  G  A  C  O  M  T  N  A  R  G  R  C
O  N  H  N  S  E  I  J  Z  B  N  N  R
O  V  F  D  N  H  I  K  D  V  F  K  U
L  E  U  P  S  I  D  J  Q  U  A  I  D
C  J  P  A  K  O  D  A  O  C  Y  Z  O
G  I  W  K  N  Z  Z  N  M  V  O  R  D
P  Q  J  G  Q  A  N  H  Y  P  I  T  T
```

3

Setting the Scene

What would *Star Wars* (1977) be without the Millennium Falcon, or *The Wizard of Oz* (1939) without Dorothy's red shoes? Would *Psycho* (1960) unnerve quite so much if the Bates Motel wasn't overshadowed by the creepy dwelling behind it? And would the alien landing site in *Close Encounters of the Third Kind* (1977) be quite as atmospheric without the presence of Wyoming's natural attraction Devils Tower?

Once a script has been greenlit, the film crew, experts in all creative and technical areas, move into action to ensure every element of a film production is in place before shooting begins. The director and producer may oversee everything, making the artistic and economic decisions that result in a film being made, but below them an army of people is divided into clearly defined departments. For each significant element of a film, from production and costume design to make-up, special effects and camera operations, there is a head of department, or HoD. It is this small group of HoDs that work closely with the director and producer, working out what needs to be created and within the costs they have been allotted. Those costs, overseen by the line producer, ensure that a film remains within a budget that has been deemed recoupable by the studio or production company.

For some departments, their work takes place once a shoot has wrapped. For others, their work is key during shooting. But for many of the roles in the making of a film, much of the work is completed before even a single second of film has been shot.

FINDING THE LOCATION

The location manager is often one of the earliest members of a crew to be involved in a production. They are responsible for finding the perfect location for a given scene. It may seem like an ideal job – scouting cities, towns and villages for a specific building to suit a story's needs, or a landscape that works within a given narrative. But it often takes years of training and finding a potential location is only a fraction of the role.

There are local and city councils to deal with, understanding ordinances and applying for permits. The role involves a significant amount of diplomacy – winning around people whose daily lives are likely to be disrupted in some way, or finding alternative accommodation or workspaces for people if you are taking over the rooms or buildings in which they live or work. Then there is the duty of care to the property a film will take place in. It's unlikely that the Duke of Northumberland would have welcomed back the crew behind *Harry Potter and the Chamber of Secrets* (2002) to Alnwick Castle had the shoot for the first film in the franchise resulted in damage to the property.

On certain films, a single location may not suffice for a sequence. The 2014 Irish Troubles thriller *'71* opens with a chase scene through Belfast's alleys. But the city had changed significantly over fifty years and so was unsuitable for what director Yann Demange required. Instead, the sequence was created by cutting between shots filmed in alleyways and backstreets in four English cities: Sheffield, Leeds, Liverpool and Blackburn. Every one of them would have had to be found by the location manager.

Alnwick Castle, England, a filming location for the first two *Harry Potter* films

THE PERFECT SPOT

La La Land (2016) was primarily filmed in the city of Los Angeles, with more than sixty different location spots chosen for their aesthetic and thematic links to the film's plot.

Imagine you are a film's location manager, looking for the perfect location spots in the city grid below. Place dots to mark out your chosen filming spots in some empty squares, while obeying the number clues given. Clues show the number of spots in touching squares – including diagonally. No more than one location spot may be placed per square, and none of them are in the numbered squares.

When complete, count up the total spots you have placed to reveal the number of Oscars that *La La Land* was nominated for.

	3		3		1	1
	3			3		
1		3	4		3	2
	2				2	
2			2			2
	2			2	2	
1			3			1

INCEPTION

None of Christopher Nolan's films evince a sense of place quite like his mind-bending 2010 blockbuster. It is not that the Gotham of his *Dark Knight* trilogy (2005–12) or the worlds created for *Interstellar* (2014) are not fully realized. His attention to detail is there for all to see in each of those films. It is more that in creating the environments for *Inception*, which journeys from Morocco to England to Canada and France, Nolan had to convince us of their real-world authenticity in order to transform them as his characters travel through the various levels of dream states that comprise his labyrinthine narrative.

Nowhere is this more impressive than in the film's early stages, on the streets of Paris. in the constructed exercises he creates for Elliot Page's novice architect Ariadne, Leonardo DiCaprio's Cobb replicates a French café, which then explodes. At the time, it was Da Stuzzi Patisserie, in the city's 7th arrondissement. They then walk along rue César Franck, which folds over on top of itself. In the next imagined scene, Ariadne constructs a bridge of mirrors, which folds in upon itself. The scene was shot on the Pont de Bir-Hakeim, a split-level road and rail bridge in the 15th and 16th arrondissements. The location had previously been used by Louis Malle for his 1958 noir thriller *Lift to the Scaffold*, Bernardo Bertolucci for an early scene in *Last Tango in Paris* (1972) and Krzysztof Kieslowski's for his *Three Colours: Blue* (1993). It may have been through these films, rather than by physically scouting a location, that Nolan and his location manager decided it was a perfect place to set the scene.

Leonardo DiCaprio and Elliot Page in *Inception*

REAL AND UNREAL LOCATIONS

Find your way through the labyrinth below, entering at the top arrow and exiting at the bottom, without retracing your steps at any point. Your route will cross under and over several bridges on the way. When you've escaped the labyrinth, count up the total number of bridges that you have neither crossed under or over to reveal the number of different countries in which *Inception* was filmed. Can you name them all?

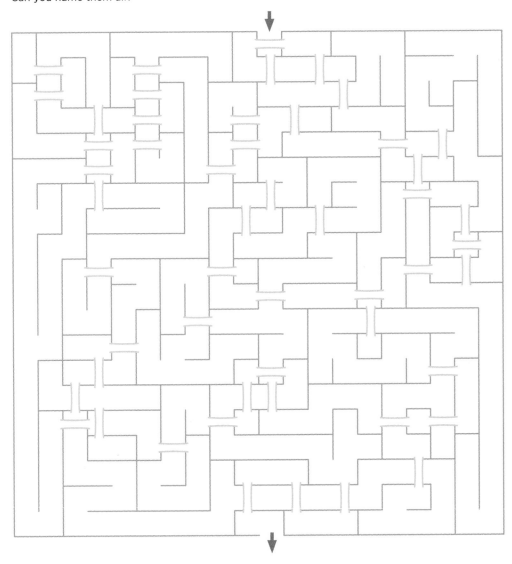

CREATING A WORLD

The filmmaking process is frequently an act of illusion – a complex play with smoke and mirrors. Finding the best way to create a world that suits a film's narrative and convinces an audience to believe in it requires more than a little manipulation. That can extend to the choice of locations. What you see in a film is not always the place you are told it is.

In his documentary *Los Angeles Plays Itself* (2003), director Thom Andersen details how the Californian city has been represented on film. He also shows ways in which it has been used as a stand-in for other cities. In the Warner Bros. gangster films of the 1930s, it was easier to film in Los Angeles than to relocate to Chicago, where most of the stories are set. But such a move had its drawbacks. In *The Public Enemy* (1931) a brief exterior shot shows James Cagney's character driving past a palm tree – a common sight in Los Angeles, but not the Windy City.

Los Angeles was not alone and the trend for using one location as a stand-in for another has not changed. Sometimes it is cheaper to shoot in a certain location. Or a different city might have architecture more in keeping with the era in which the film's action is set. The western *The Power of the Dog* (2021) is set in Montana, but it was shot in New Zealand. Prague played host to *The Bourne Identity* (2002), *Oliver Twist* (2005) and *Child 44* (2015), apparently a perfect stand-in for, respectively, Zurich, London and the former Soviet Union. Then there is the thrilling opening sequence of *World War Z* (2013), which unfolds in Philadelphia. But as anyone from Glasgow will know, it is George Square in the Scottish city.

Benedict Cumberbatch in Jane Campion's *The Power of the Dog*

WORLDS APART

Each of the six films listed immediately below was set in a different location to the one in which it was actually filmed. In each line of letters alongside the film titles, these two places – the setting and the country of filming – have been blended together, with all of the letters remaining in the correct order for each word. Any spaces have been ignored.

First of all, separate the locations and settings, then match each pair to one of the given movies to identify where it was both set and shot. The two lists are not in the same order.

1. *Apocalypse Now* (1979)

2. *Mad Max: Fury Road* (2015)

3. *The Mummy* (1999)

4. *Les Misérables* (2012)

5. *The Revenant* (2015)

6. *Gladiator* (2000)

A. EMGORYOCPCTO

B. FENRGALNANCDE

C. MIALTALTAY

D. NAUAMSITBRIALAIA

E. PVHILIEIPTNPAINMES

F. UANRIGTENETDSITNATAES

- -

LOCATION TRIVIA

Name the cities these films are set in:

1. *Blade Runner* (1982)
2. *Akira* (1988)
3. *Muriel's Wedding* (1994)
4. *Trainspotting* (1996)
5. *Run Lola Run* (1998)
6. *All About My Mother* (1999)
7. *Amélie* (2001)
8. *City of God* (2002)
9. *Roma* (2018)
10. *Living* (2022)

PARASITE

Korean writer-director Bong Joon-ho's 2019 satirical thriller, the first non-English-language film to win the Best Picture Oscar, revolves around the lives of two families from opposite ends of the economic spectrum. Their fortunes are represented by the space each family occupies. The wealthy Park family live in a gated, split-level household, while the Kims are crammed into a paltry basement flat. One has views over the city, the other resides at the bottom of a street.

Both locations were created by Bong with production designer Lee Ha-jun, art directors Se-jin Lim and So-ra Mo, and set dresser Won-woo Cho. Their aim was to emphasize the film's main theme of the disparity between lives in one, seemingly homogenous, society.

The Park residence was divided into two separate builds. The ground floor and garden were built on an outside studio lot, while the first floor and basement were constructed on a studio set. Although there is much camera movement throughout the film, fluid editing gives the impression of one interconnected location. By contrast, the Kim residence was a trickier build. The basement apartment and connecting street were all built in a vast tank so that the entire set could be flooded with water in the rainstorm sequence. Once these were built, locations were found around Seoul that would not only create a physical, real-world link between these two sites, but also give the sense of the Park home existing high above that of the Kims.

Park So-dam and Choi Woo-sik in *Parasite*

STACKED ODDS

Complete the number pyramid below so that each brick contains the sum of the two 'bricks' immediately beneath it. When the puzzle is complete, the number at the top will reveal the number of years it would take for the character Kim Ki-woo to purchase the Park family home, according to the film's director.

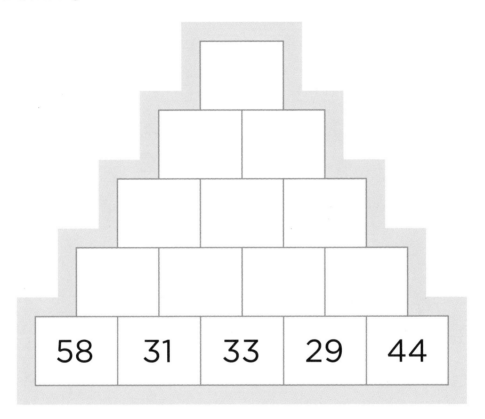

| 58 | 31 | 33 | 29 | 44 |

BONG JOON-HO TRIVIA

Match each description below with one of these films by Bong Joon-ho:

A. *Memories of Murder* (2003)

B. *The Host* (2006)

C. *Snowpiercer* (2013)

D. *Okja* (2017)

1. In a post-apocalyptic world, a train perpetually circumnavigates the globe.

2. A girl befriends a genetically engineered pig and fights to save its life.

3. A cop becomes obsessed with a serial killer.

4. A monster is terrorizing downtown Seoul.

PRODUCTION DESIGN

The main responsibility for creating a world or transforming a real one into the location in which a sequence unfolds, comes down to the production designer. Working with the art designers and set dressers, they are responsible for pretty much everything that can be seen on the screen, even ensuring that any visual effects created in post-production work in tandem with what has been shot.

Before the shoot begins, the production designer will have worked with the director and other heads of department, such as the cinematographer, art designer and set dresser, to ensure that every aspect of a film's visual style is in perfect synthesis with the demands of the script and the director's vision. The production designer then ensures that the art designer and set dresser coordinate with their teams of craftspeople to realize this world, from the building of sets, additional builds to existing locations and the creation of all props.

One of the finest examples of how the production designer can transform a space is the use of the legendary Bradbury Building in downtown Los Angeles. Built in 1893, its exterior employs the Italian Renaissance revival style that was popular at the time. But it is the meticulously designed ironwork interiors that make it so iconic. It was a popular location in LA-set film noirs, most notably as an office space in both *Double Indemnity* (1944) and *D.O.A.* (1950). It appeared in the late 1960s detective thriller *Marlowe* (1969) and helped recreate the 1930s for *Chinatown* (1974). In 1994 it featured significantly in both *Disclosure* and *Wolf*, while its beautifully designed staircases and atrium made it a perfect setting for scenes in *The Artist* (2011). But the location's most iconic appearance was as the expansive, yet dilapidated home of robot designer J.F. Sebastian in the 1982 sci-fi classic *Blade Runner*.

Harrison Ford in Ridley Scott's *Blade Runner*

SAME BUT DIFFERENT

Each of these eight numbered locations has played host to
one of the eight lettered pairs of films listed beneath – that is,
the two different films were shot in the same place. Can you
match each pair with its location?

1. **Quality Café, Los Angeles**

2. **Hatfield House, Hertfordshire**

3. **Fox Plaza, Los Angeles**

4. **The Bradbury Building, Los Angeles**

5. **John Marshall High, Los Angeles**

6. **The Cliffs of Moher, County Clare**

7. **Kilmainham Gaol, Dublin**

8. **Acton Lane Power Station, London**

A. *Batman* (1989) **and** *Aliens* (1986)

B. *Speed* (1994) **and** *Die Hard* (1988)

C. *The Favourite* (2018) **and** *Sherlock Holmes* (2009)

D. *Grease* (1978) **and** *Pretty in Pink* (1986)

E. *Paddington 2* (2017) **and** *The Italian Job* (1969)

F. *Million Dollar Baby* (2004) **and** *Catch Me If You Can* (2002)

G. *500 Days of Summer* (2009) **and** *The Artist* (2011)

H. *The Princess Bride* (1987) **and** *Harry Potter
 and the Half-Blood Prince* (2009)

BEN-HUR AND GLADIATOR

There can be no greater contrast between the way film technology has changed than in the production history behind two of the most acclaimed Roman epics.

Ben-Hur (1959), which held the record for the most Oscar wins for almost forty years, was directed by William Wyler at the height of the popularity of the biblical epic in the 1950s. The genre had previously enjoyed a halcyon period in the silent era and returned to cinemas as a way of countering the increasing popularity of television and to showcase advances in colour and widescreen formats. Ridley Scott's *Gladiator* (2000), which picked up four Oscars, for Best Picture, Best Actor for Russell Crowe, and technical awards for sound and visual effects, was something of an outlier – not just a rare return in cinema to ancient history, but also one that became a global commercial hit.

Wyler's film was produced in an age when an army of craftspeople were involved in building huge sets and before computer-generated imagery could conjure up any era or world. The most significant set pieces, including the breathtaking chariot race, were filmed at the legendary Cinecittà Studios on the outskirts of Rome. Five years of research went into the creation of 300 sets, which would be populated with more than 10,000 extras. Scott's film, for which he cited both *Ben-Hur* and *Spartacus* (1960) as primary influences, combined traditional craft with modern technology. Rome's towering Colosseum was only constructed in part. The base and lower third were made mostly of plaster and plywood, with the remaining two thirds and much of the crowd created digitally in post-production.

Filming *Gladiator*

ON A BIBLICAL SCALE

Can you use your mathematical skills to reveal more behind-the-scenes information about *Ben-Hur*? Starting with the number on the left of each chain, perform each of the mathematical operations in turn from left to right. In the final, empty box, write in the resulting number to reveal the solution to the clue given above each number chain.

1. **The number of Oscars won by the film, including Best Picture.**

| 15 | + 48 | ÷ 9 | x 2 | - 3 | |

2. **The number of camels reportedly used for the film.**

| 34 | x 8 | + 28 | ÷ 3 | x 2 | |

3. **The number of horses reportedly used for the film.**

| 5 | x 5 | x 4 | x 5 | x 5 | |

4. **The year in which the film's action begins: AD_____**

| 64 | ÷ 4 | + 22 | ÷ 2 | + 7 | |

RECREATING THE PAST

The bedrock of any craft department lies in research. Nowhere is this more important than in the recreation of the past. But the cinematic representation of bygone eras does not necessarily mean remaining steadfast to a high degree of verisimilitude. It lies more in deciding in pre-production how the past will appear in a film and maintaining the logic of the universe that has been decided upon.

For instance, few people would believe that the sword-and-sandal epics of classical Hollywood are perfect representations of the era in which they are set. Whether it is the story of Moses in *The Ten Commandments* (1956) or the lavish lifestyles of the Roman elite in *Spartacus* (1960), these films balance research into their given eras with no small amount of creative freedom to conjure up elements that may lie beyond historical facts.

More recent history is easier to research, but a filmmaker may still wish to 'play' with the available history. Yorgos Lanthimos is a filmmaker known for his singular perspective on the world. When he approached the making of *The Favourite* (2018), the eighteenth-century tale of two courtiers attempting to win the favour of Queen Anne, he embraced anachronisms. The world the characters occupy – the film was mostly shot in a Jacobean country house in the English county of Hertfordshire – gave a powerful sense of the era, but Lanthimos and cinematographer Robbie Ryan's use of wide-angle lenses, and the contemporary feel of the performances, underpinned the filmmaker's belief that recreating the past can only be done convincingly up to a point.

Olivia Colman, Emma Stone and director Yorgos Lanthimos on the set of *The Favourite*

ALL IN ORDER

Can you arrange these period films into chronological order of setting, with that set furthest back in time first? Note that some films are set in the future.

When complete, read the letters next to each film in chronological order of setting

to reveal the name of a final film. The film in question was banned in some countries at the time of its release, precisely because it was set, and released, in the same time period. Can you name the film, and guess why its contemporary setting may have led to a ban?

Chicago (2002) – **L**

Gladiator (2000) – **C**

Hidden Figures (2016) – **A**

I, Tonya (2017) – **N**

Interstellar (2014) – **A**

Marie Antoinette (2006) – **A**

Metropolis (1927) – **C**

Portrait of a Lady on Fire (2019) – **B**

Shakespeare in Love (1998) – **S**

The Adventures of Robin Hood (1938) – **A**

- -

PERIOD FILM TRIVIA

1. Which city featured in a musical set at the end of the nineteenth century starring Ewan McGregor and Nicole Kidman?
2. Steven Spielberg has directed four films featuring the same central character, but set at different points in the twentieth century. Name the character and the actor who plays him.
3. Which musically themed Jane Campion film is set in mid-nineteenth-century New Zealand?
4. Which two of these period films, all released in the 2010s, did not win the Best Picture Oscar?
 The King's Speech, *Argo*, *Green Book*, *1917*, *The Artist*, *Django Unchained*, *12 Years a Slave*, or *Spotlight*?
5. Which titular character, based on Edmond Rostand's 1897 stage play, was portrayed by Gérard Depardieu in a hugely successful 1990 French adaptation?

THE LEOPARD

When it comes to opulence – the bold vision of a director, the lavish sets upon which a story unfolds and the meticulously crafted costumes worn by characters – few films can compare with Italian filmmaker Luchino Visconti's 1963 epic.

Adapted from the first two-thirds of aristocrat and novelist Giuseppe Tomasi di Lampedusa's 1958 eponymous novel, *The Leopard* focuses on the world of Don Fabrizio Corbera, Prince of Salina, during the 1860s, when the Risorgimento – Italian unification – was well underway. He was played by Burt Lancaster, casting that producers hoped would guarantee the film's appeal to international audiences. (The film was even shot in different languages, with actors dubbed for each version produced.) The research into the era was meticulous, with Visconti keen to capture every detail correctly.

The location shoot, which included two months spent in Sicily for the film's epic battle scenes, would last twenty-two weeks. But the most significant section of the film is the ballroom sequence that takes up almost a quarter of the running time. Here, the filmmaker emphasizes the pageantry of the event, viewed as a last gasp for a class whose days were numbered. It begins with the arrival of the main characters – Don Fabrizio's family, most notably his daughter, played by Italian star Claudia Cardinale, and her fiancé, played by French leading man Alain Delon. But then Visconti's camera becomes a character in itself, roaming the many rooms where the ball is held, even dancing around the actors in the main ballroom. The sequence would become a key influence for Martin Scorsese when he adapted the Edith Wharton novel *The Age of Innocence* (1993).

Burt Lancaster and Claudia Cardinale lead the dance in the climactic sequence of Luchino Visconti's *The Leopard*

HAVING A BALL

Imagine you are choreographing *The Leopard*'s famous ballroom scene, carefully planning out the movements of each couple to allow for a free-roaming camera. Can you match up these dancers into pairs so that no couple encroaches upon any other?

To do so, draw horizontal and vertical lines to join the dancers into pairs, so that each pair contains one grey dancer and one blue dancer. Lines cannot cross either another line or a dancer.

COSTUME DESIGN

What would *Cleopatra* (1963) be without the golden headdress that Renié designed for Elizabeth Taylor, or Colleen Atwood's skin-like outfit for Johnny Depp in *Edward Scissorhands* (1990)? Would Bette Davis convey such a powerful sense of transformation without the presence of Orry-Kelly's hat in *Now, Voyager* (1942) or the digital world of *The Matrix* (1999) be the same stylish vision imagined by the Wachowskis if Kym Barrett's leather outfits did not adorn Keanu Reeves and Carrie-Anne Moss? And what would the Golden Age of Hollywood have looked like without Edith Head's astonishing talent being brought to bear on more than four hundred films?

The costume designer is an essential part of the filmmaking process. They add to the authenticity of a film, whether it is a period drama or a contemporary comedy. Like every other part of the production process, there is not a single element that does not pass through the gaze of the costume designer and their department. That may seem a given when it comes to a Baz Luhrmann film like *Moulin Rouge!* (2001) or *Elvis* (2022), which revels in the rococo splendour of its characters' wardrobe. But it is just as important for less obvious clothing items. Take the T-shirt Marlon Brando wears in *A Streetcar Named Desire* (1951), or the one worn by Brad Pitt's character in *Once Upon a Time in Hollywood* (2019). Designed, respectively, by Lucinda Ballard and Arianne Phillips, they play an essential role in defining the characters of Stanley Kowalski and Cliff Booth. That's exactly the role that any character outfit should play – working in tandem with the rest of the film in building a character and convincing audiences that the world they are watching is real, at least while the film is playing.

Johnny Depp as Edward Scissorhands

BEST DRESSED

Each of these close-up photographs features an iconic costume worn by a lead character in a film. Which film is each image taken from? Can you name the character wearing the costume and the actress who played the character?

A

B

C

D

THE BATMAN FILMS

Robert Pattinson's version of Batman in Matt Reeves' 2022 adaptation of the DC superhero is a grungier take on a character who was created in 1939 and has been a presence on the big screen since 1966. Adam West's version of the character, which opened in cinemas just after the first season of the TV series had aired in the mid-1960s, cemented the character within popular culture. Since then, the dark knight has transformed considerably with each incarnation, as has his costume.

West's caped crusader, like the rest of the cast and the film's script, revelled in campness. His outfit was little more than tight-fitting spandex. When Batman returned in Tim Burton's eponymous 1989 blockbuster and its 1992 sequel, the bat suit had become considerably more stylized – a reflection of the filmmaker's more Gothic tendencies. When Joel Schumacher replaced Burton on *Batman Forever* (1995), the bat suit looked less menacing, reflecting the film's shift in tone. Schumacher went further on *Batman & Robin* (1997), with Batman's breastplate famously sporting nipples.

Christopher Nolan's *Dark Knight* trilogy (2005–12) incorporated discussion about the bat suit's durability within its narrative. Unlike the Zack Snyder versions that followed, *Batman v Superman: Dawn of Justice* (2016) and *Justice League* (2017–21), which emphasized Ben Affleck's larger physique, Nolan's version, encased around Christian Bale, made a point of showing the character's physical vulnerability and the cost to Bruce Wayne of pushing himself. It is this approach that Reeves and Pattinson have taken with the latest incarnation of Bob Kane and Bill Finger's crime-fighting character – his suit merely a veneer to hide his identity and protect a body that has no superhuman power of its own.

Robert Pattinson as Batman

FIND THE STARS

Batman, his friends and his foes have been played by several famous faces since the first film appearance in 1966. Can you find the capitalized surnames of each of these actors in the grid below? The names may be written in any direction.

Batman
Adam WEST
Michael KEATON
Val KILMER
George CLOONEY
Will ARNETT
Christian BALE
Ben AFFLECK
Robert PATTINSON

Joker
Cesar ROMERO
Jack NICHOLSON
Zach GALIFIANAKIS
Heath LEDGER
Jared LETO

Penguin
Burgess MEREDITH
Danny DEVITO
Colin FARRELL

Catwoman
Lee MERIWETHER
Michelle PFEIFFER
Zoe KRAVITZ
Anne HATHAWAY

Riddler
Frank GORSHIN
Jim CARREY
Paul DANO

Robin
Burt WARD
Chris O'DONNELL
Michael CERA

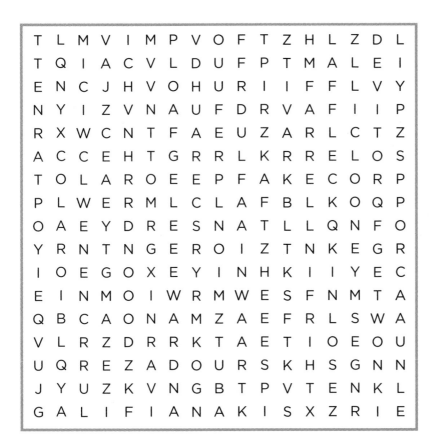

```
T L M V I M P V O F T Z H L Z D L
T Q I A C V L D U F P T M A L E I
E N C J H V O H U R I I F F L V Y
N Y I Z V N A U F D R V A F I I P
R X W C N T F A E U Z A R L C T Z
A C C E H T G R R L K R R E L O S
T O L A R O E E P F A K E C O R P
P L W E R M L C L A F B L K O Q P
O A E Y D R E S N A T L L Q N F O
Y R N T N G E R O I Z T N K E G R
I O E G O X E Y I N H K I I Y E C
E I N M O I W R M W E S F N M T A
Q B C A O N A M Z A E F R L S W A
V L R Z D R R K T A E T I O E O U
U Q R E Z A D O U R S K H S G N N
J Y U Z K V N G B T P V T E N K L
G A L I F I A N A K I S X Z R I E
```

MAKE-UP

The make-up department on any film works closely with costume design, ensuring that all shades and colours complement a character's overall image, or are intended to contrast in some way. The two departments then work with the cinematographer in ensuring that everything coordinates with the specific visual style a director is seeking. It is important, because a film drained of most of its colour, such as *Saving Private Ryan* (1998), will require a different approach to make-up than a more conventional period drama might require.

A make-up department covers a wide spectrum of roles. There is the conventional use of make-up, as people employ in everyday situations. It may be exaggerated at times, depending on the demands of the script or a given scene. (Early cinema did so as a norm, accentuating a more declamatory style of acting.) It also covers all types of hair. And when it is a war or horror film, the make-up department is essential in creating everything from the detritus of a battle scene to a bloodbath. In the past, make-up artists would work with prosthetics to create limbs, scars or other, more extreme effects. In recent years, complex make-up is often combined with visual effects created in post-production. But even with such changes in technology, the make-up department is still the first department on set every day, making sure each actor is ready for their scene and sometimes, as was the case with Marlon Brando in *The Godfather* (1972), Charlize Theron in *Monster* (2003), Marion Cotillard in *La Vie en Rose* (2007), Heath Ledger in *The Dark Knight* (2008) or Christian Bale in *Vice* (2018), spending hours on transforming a star into their character.

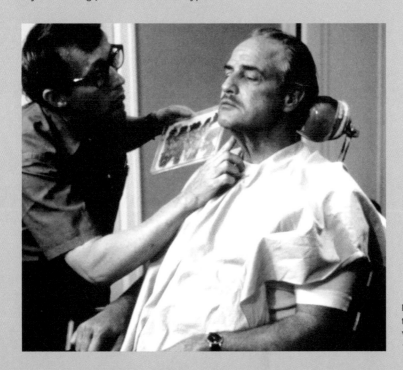

Marlon Brando being transformed into Vito Corleone for *The Godfather*

THE EYES HAVE IT

Each of these pairs of made-up eyes can
be spotted in a well-known movie. For each
image, can you say which character is shown,
and from what film?

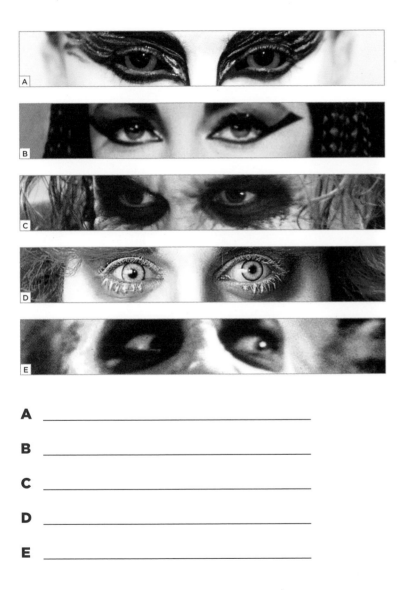

A _____

B _____

C _____

D _____

E _____

PROSTHETICS

From changing the shape of an actor's nose to transforming them into a monster, prosthetic artists have been a constant presence, in tandem with their make-up counterparts – often overlapping – since the early days of cinema. The creation of prosthetics can be a long and painstaking process, taking moulds of the part of an actor's body to be transformed and building a credible extension to their physique.

Early examples include the transformation of actor Lon Chaney in *The Hunchback of Notre Dame* (1923) and *The Phantom of the Opera* (1925). Jack Pierce was a pioneer, whose work, particularly with Universal at a time when their monster series was popular, can be seen on productions like *Frankenstein* (1931) and *The Wolf Man* (1941). John Chambers went further, creating a population of simians for the original *Planet of the Apes* series of films (1968–73),

while Dick Smith took horror make-up to a new level with his work on *The Exorcist* (1973).

For *The Elephant Man* (1980), make-up artist Christopher Tucker used casts of Joseph Merrick's body to create the prosthetics worn by John Hurt, highlighting the detailed research that often goes into the creation of a character's physical features. A year later, the effects created by Rick Baker for *An American Werewolf in London* (1981), which detail on camera the main protagonist's transformation into a lycan, proved to be a landmark of in-camera effects. In future years, the process would be made easier with the combined use of digital effects. A perfect example of this is the 600-pound character Brendan Fraser transformed himself into, with the use of prosthetics and CGI technology for the psychological drama *The Whale* (2022).

John Hurt as John Merrick in David Lynch's film, *The Elephant Man*

A LITTLE ADDED EXTRA

On each line below, the surname of an actor, the name of a character they play and the title of the film they appear in have all been spliced together in a somewhat unnatural way, with parts of each appearing on a single line. Each of these characters is notable for their use of prosthetics in the named film.

Can you work out which actor, character and film have been glued together on each line?

1. OLDMURCHILSTHOUR (2017)

2. BRANDRLEONEDFATHER (1972)

3. CDIARMILPATINEHEJEDI (1983)

4. KIDMAOOLFEHOURS (2002)

5. EESONEYEMOODYOBLETOFFIRE (2005)

6. ONHAMCAREDQUEEONDERLAND (2010)

1. Surname/character: _____

 Film: _____

2. Surname/character: _____

 Film: _____

3. Surname/character: _____

 Film: _____

4. Surname/character: _____

 Film: _____

5. Surname/character: _____

 Film: _____

6. Surname/character: _____

 Film: _____

SPECIAL EFFECTS

The terms 'special effects' and 'visual effects' may sound interchangeable, but they are two very distinct functions within film production. Special effects are the physical in-camera effects, created on set. Visual effects are what's added in post-production.

The former have been a mainstay of cinema, going all the way back to the early, illusion-driven films of Georges Méliès. Special effects can encompass mechanized props, animatronics, the use of scale models and pyrotechnics. Special effects teams will work in close cooperation with other departments, such as make-up and prosthetics, to create the illusion of a specific stunt or character transformation. And they work closely with visual effects teams. For instance, many of the effects employed in *Jurassic Park* (1993) were the result of groundbreaking digital software. But in one sequence, where Sam

Neill and Laura Dern's palaeontologists tend to an injured creature, the special effects department created it as a living, breathing, fully physical presence. The close collaboration of the two departments ensure that all dinosaurs are of a piece with the world being created.

What special effects can do is give the audience the thrill of knowing that what they are seeing was actually filmed and not created in a computer. It is part of the allure of Tom Cruise's star persona – audiences know that he does many of the stunts himself, supported by an expert team of special effects supervisors. And contemporary special effects departments are as advanced technologically as their visual effects counterparts, to ensure that any effect is controlled and reduces any risk of harm to actors and crew.

Laura Dern and Sam Neill in *Jurassic Park*

DIGITAL DRAWING

Imagine you are putting together sketches for the visual effects used in *Jurassic Park*. Can you follow the instructions in the next column to reveal a basic outline of a particular dinosaur spotted in the film franchise?

To reveal the image, shade some squares according to the given clue numbers. The clues provide, in reading order from left to right or top to bottom, the length of every run of consecutive shaded squares in each row and column. There must be a gap of at least one empty square between each run of shaded squares in the same row or column.

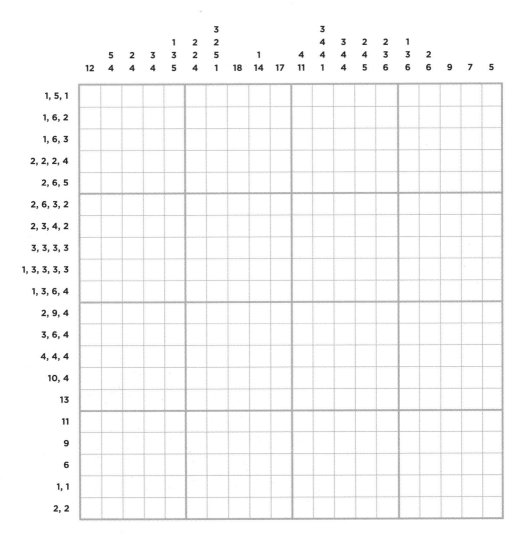

NO TIME TO DIE

Most Bond films are enjoyed for their action set pieces, and the most memorable of these tend to be driven by special rather than visual effects. Just as Christopher Nolan prefers to shoot complex action sequences in camera – from the upended lorry in *The Dark Knight* (2008) to the tumbling corridor fight sequence in *Inception* (2010), so many Bond directors have employed the skills of special effects supervisors to create convincing real-world action sequences.

Nowhere is this more apparent than in *No Time to Die* (2021). Like the Daniel Craig entries in the Bond franchise before it – which arguably drew from the no-frills action of the Jason Bourne series (2002–16) – Cary Fukunaga's action thriller avoids the more kitsch, less credible elements that marred a number of the earlier Bond films in favour of a grittier, more down-to-earth approach to the major

set pieces. This likely placed more demand on the special effects supervisors, with visual effects departments embellishing on what had already been recorded in camera.

The pre-credit sequence in Italy sets up the style of the film. It combines pyrotechnics – the explosion that begins the sequence – with a stunt double jumping 75 m (250 ft) off a bridge, followed by choreographed car and bike chase through an ancient town. The sequence is a marvel of editing – the location is a combination of three towns in southern Italy. Production designers will have worked with the special effects team to ensure that the shoot-out in Matera's Piazza San Giovanni Battista, with Bond's Aston Martin DB5 doughnutting as it lets out a stream of rapid gunfire, looked authentic without damaging any of the surrounding thirteenth-century architecture.

No Time to Die

Imagine you are choreographing the opening car-chase sequence in *No Time to Die*. Can you plot out a circular route through the city grid below, while avoiding the shaded squares?

Draw a loop that visits every white square, without visiting any square more than once. The loop must be made up only of horizontal and vertical lines, and cannot enter any shaded squares.

4

The Director's Chair

Creatively, the film director is the person who calls the shots. Literally. They are responsible for bringing the whole film together and it is with their name, save for the involvement of a star, that a film becomes most closely associated.

Film directors were once anonymous figures. Even with the arrival of the feature-length film, the producer was often promoted as the most significant figure in any production. But in experimental and art films, the director was held in higher esteem. Gradually, as certain directors became known for embracing a specific style or genre of filmmaking, the notion of that role as the dominant creative force became more widespread. For some people, they were, above all others – even the screenwriter – the authors of the work. This was popularized by the *auteur* theory, which gained ground in the 1950s and 1960s among a group of French critics who identified a definitive style in the work of certain directors. This idea also caught on with US critics, with filmmakers like John Ford, Alfred Hitchcock, Jean Renoir and Howard Hawks lifted into the pantheon of greatest filmmakers because of the preoccupations that ran through their work. The arrival of a new generation of filmmakers in the US at the end of the 1960s only exacerbated this notion. Today, the director is seen as the dominant creative force in a film. Some directors have become household names – so familiar that they are referred to by just one name, whether it's Scorsese, Almodóvar, Spielberg or Tarantino.

PIONEERS

Early cinema did little more than record the world around us, in a single shot, before pioneering filmmakers expanded the possibilities of the medium.

With his landmark shorts *Life of an American Fireman* and *The Great Train Robbery* (both 1903), Edwin S. Porter experimented with editing, allowing audiences to witness events unfolding in two places at the same time. This was taken further by D.W. Griffith, who transformed parallel editing, as it became known, into an art form. In films like *The Birth of a Nation* (1915) and *Intolerance* (1916), he created complex timeframes, made simple for audiences to follow because of his skill in editing them together. This would be taken to extremes a decade later by Soviet directors like Sergei Eisenstein and Dziga Vertov, whose *Battleship Potemkin* (1925) and *Man with a Movie Camera* (1929) employed editing to

create meaning, often politically charged, through the editing process.

Pioneering filmmakers also played with scale. If Italian director Giovanni Pastrone's vast *Cabiria* (1914) marked an early high point for the historical epic – rivalled by the work of Hollywood director Cecil B. DeMille in films like *The Ten Commandments* (1923) – Fritz Lang with his sci-fi spectacular *Metropolis* (1927) presented imagined worlds on an astonishing scale. Other filmmakers worked on a more intimate level to equally stunning effect. Lang's fellow German F.W. Murnau, with his *Nosferatu* (1922), *The Last Laugh* (1924) and *Sunrise: A Song of Two Humans* (1927), saw in cinema a poetic medium, with movement conveying its own subtle language. It was these early pioneers who created a grammar of film – a language that is still used by filmmakers today.

Dziga Vertov's
*Man with a
Movie Camera*

PIONEERS

Each of these film directors can be considered a pioneer in their field, whether through the introduction of new filming techniques or even by having kicked off a whole cultural movement. Highlight their achievements by finding each of their names in the word-search grid below. The names can be read in any direction, and may overlap.

AGNES VARDA

ALFRED HITCHCOCK

ALICE GUY BLACHE

FRANCOIS TRUFFAUT

FRANK CAPRA

FRITZ LANG

GASTON VELLE

GEORGE MELIES

JEAN RENOIR

LUIS BUNUEL

MARY ELLEN BUTE

NICHOLAS RAY

ORSON WELLES

OSCAR MICHEAUX

SERGEI EISENSTEIN

WERNER HERZOG

```
P E K N Z P J S O U T G Y S Z C Y Y N
T E L T Q R E S E L L E W N O S R O I
Y U A L S R L T U Q I T A R F S S J C
D K A B E E X P U M X G F R Z C P A H
G K M F V V J I J B F H A N A G A D O
G C S B F P N L Q R N N L R Y L E R L
F O W O T U U O I J K E M D I L G A A
L C Z Z Q H R T T C E I L C W E H V S
L H Z R P K Z T A S C A E L O I H S R
E C D H E L Y P S H A G N R E G A E A
U T C J A H R N E I U G G R L Y P N Y
N I V N X A R A P Y O E W E E Y R G M
U H G Y Q A U E B R M C H Z M N R A O
B D F X Z X W L N E G E N M K N O M M
S E L L O R A L L R R A S A R F W I L
I R Y N D C B I R N E Z Z E R O W D R
U F B Q H A E T D U Z W Q V F F G G S
L L O E X S D R U W P T T F P H V Z D
S A S E R G E I E I S E N S T E I N M
```

CHARLES CHAPLIN

A prodigy on the stage who took to cinema like a duck to water, Charles Chaplin was born in 1889 into poverty and suffering on the streets of south London. He made his first stage appearance, in a music hall, around the age of five. By sixteen, he was on the West End stage and two years later he joined a theatre troupe on a tour of the US. It was on his second American tour that he received an offer to work in film.

At the beginning of 1914, Chaplin started working with the Keystone Film Company and was quick to learn as much as he could about how films were produced. His first public screen appearance was in *Kid Auto Races at Venice*. Soon after, he began developing his little tramp persona, which proved popular with audiences and made him a star. He moved into directing while continuing acting, building an impressive knowledge of every aspect of the filmmaking process. By the time of his feature debut *The Kid* (1921), Chaplin was one of the biggest stars in the world. He would remain so for the whole of the 1920s.

Through a series of hit films over two decades, including *The Gold Rush* (1925), *The Circus* (1928), *City Lights* (1931), *Modern Times* (1936) and *The Great Dictator* (1940), Chaplin would achieve a level of fame previously unheard of. His private life and his politics would eventually derail his career, while the streak of sentiment that ran through his work would become unfashionable. But his brilliance as a comedian, the pathos of his work and his compassion are plain to see in these films, which delight and move in equal measure.

Charles Chaplin promoting his most enduring screen persona

SILENT CHAPLIN

Charlie Chaplin became known first and foremost as a star of silent movies, and only later in his career did he move into the now ubiquitous 'talkie' format. Each of the films listed below is the title of a silent movie in which Chaplin starred, either of short or feature length.

All of the titles should consist of 'The', plus one additional word. Each of the additional words, however, has been joined by several 'silent' letters. Can you delete one letter from each pair to reveal the full list of films?

1. **THE** GR IA LN KS

2. **THE** CO BU RS EN

3. **THE** RB OA WN KD

4. **THE** CK OE FU LN TY

5. **THE** TW RE SA OM PN

6. **THE** FN KI RA OE SM IA ND

7. **THE** VZ OA GR CA LB OE YN DP

8. **THE** IO LM MR TI NG ER AO NT ST

9. **THE** KQ UN EO CG HK EO UD TM

10. **THE** CA DL EV ME SN IT UE GR LE RE

11. **THE** OM AR RS QT UI LE RF AE ND TE YR

- -

CHAPLIN TRIVIA

1. Place these Chaplin features in order of their release:
 - *Modern Times*
 - *Monsieur Verdoux*
 - *A Woman of Paris*
 - *Limelight*

2. Which Marvel star played Chaplin in Richard Attenborough's 1992 biopic?

3. In which city was Charles Chaplin born?

ALFRED HITCHCOCK

Mastering the art of the thriller, plumbing the darker side of human nature, Alfred Hitchcock was a skilled filmmaker whose immense body of work remains one of the most influential of any director. Just as John Ford gave the western mythic status, Hitchcock elevated the thriller to an art form. His wizardry with the camera was wildly innovative, while his more mischievous side pushed at the boundary of what was morally acceptable.

Born in East London in 1899, Hitchcock joined the film industry in his early twenties, first writing scenarios before moving into direction. He visited the German UFA studios where he saw German expressionist filmmakers at work. He would also have seen the Soviet films made around the same time, with their radical experiments in editing. Both fed into his own films. His third feature, and first legitimate thriller, *The Lodger: A Story of the London Fog* (1926), is regarded as his first masterpiece. With the coming of sound, he continued to innovate, with *Blackmail*, *The Man Who Knew Too Much*, *The 39 Steps* and *The Lady Vanishes*, all released in the late 1920s and 1930s. He moved to Hollywood in 1939, debuting with the Oscar-winning *Rebecca*. Over the next twenty years he was responsible for the masterpieces *Shadow of a Doubt*, *Notorious*, *Strangers on a Train*, *Rear Window*, *Vertigo* and *North by Northwest*. In the 1960s,

Psycho, which he mostly funded himself, pushed the horror film into the modern age, while *The Birds* and *Marnie* were troubling and compelling psychodramas. His final film was *Family Plot* (1976), marking fifty films over as many years and cementing his reputation as one of the greatest filmmakers ever.

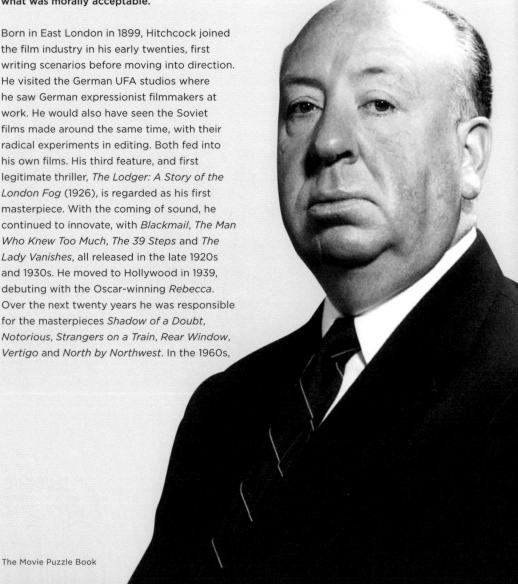

DATING HITCHCOCK

Can you rearrange these Hitchcock films into chronological order of release date? Once you have decided on the order, read the letters that accompany each film in order from first- to last-released to spell out the name of a close collaborator. The film with no letter will create a space between first and last names.

A *Easy Virtue*

A *The 39 Steps*

E *Rear Window*

E *The Birds*

I *Vertigo*

L *Blackmail*

L *North by Northwest*

L *Psycho*

M *The Man Who Knew Too Much*

R *Stage Fright*

V *To Catch a Thief*

Rebecca

- -

HITCHCOCK TRIVIA

1. Which two of the following films each starred Cary Grant and James Stewart:
 - *Notorious*
 - *Rear Window*
 - *To Catch a Thief*
 - *The Man Who Knew Too Much*

2. Each of the following actresses starred in two of the films listed below: Tippi Hedren, Joan Fontaine, Ingrid Bergman and Grace Kelly. Allocate each film to an actress:
 - *To Catch a Thief*
 - *Marnie*
 - *Notorious*
 - *The Birds*
 - *Dial M for Murder*
 - *Spellbound*
 - *Suspicion*
 - *Rebecca*

AKIRA KUROSAWA

In 1951, Akira Kurosawa won the Golden Lion, the top film at the Venice International Film Festival, for his multi-perspective murder mystery *Rashomon* (1950). It not only established him on the world stage, the film's success also opened the floodgates of international interest in Japanese cinema.

To watch a Kurosawa film is to witness a maelstrom of human affairs, the turbulence faced by his characters is often reflected in the elements – rain and storms dominate his most famous works, whether it is the incessant downpour in *Rashomon* or the storm that transforms the climactic battle in the celebrated *Seven Samurai* (1954) into a deluge of chaos and violence. Kurosawa's films dealt with Japan's feudal past and its post-war present, but in exploring the human condition through the frailties, failings, compassion and cruelty of his characters, his films spoke out to a universal audience.

Kurosawa was steeped in a love of Western literature and Hollywood cinema. He was fascinated by the westerns of Hollywood director John Ford. He adapted Russian novelists Gorky, Dostoevsky and Tolstoy for the screen. And he took on Shakespeare for three films – *Macbeth* for *Throne of Blood* (1957), *Hamlet* for *The Bad Sleep Well* (1960) and *King Lear* for *Ran* (1985). In turn, his own work would become hugely influential. George Lucas cites *The Hidden Fortress* (1958) as a major inspiration – both in tone and narrative, for *Star Wars* (1977). The Samurai action film *Yojimbo* (1961) was remade as *A Fistful of Dollars* (1964). And, most famously, *Seven Samurai* was transformed into the western *The Magnificent Seven* (1960).

Seven Samurai

KUROSAWA CUTS

Kurosawa worked both as a director and editor on his films, and became known for his inventive use of cutting techniques. Can you piece together the titles of five of his best-known films, which have been cut into smaller segments and reordered?

Write out the restored titles in the gaps provided, one letter per underline. Spaces between words were removed during the cutting process.

AI	DAL	EGRE	ENSA
EOFB	IDDE	LO	MUR
NFOR	NOR	OD	ON
ROU	RYO	SCAN	SEV
SS	THEH	THR	TRE
	TSFO	UTH	

1. _ _ _ _ _ _ _ _ _ _ _ _ _ _ _ _ _ _ _ _

2. _ _ _ _ _ _ _

3. _ _ _ _ _ _ _ _ _ _ _ _

4. _ _ _ _ _ _ _ _ _ _ _ _ _ _ _ _ _ _

5. _ _ _ _ _ _ _ _ _ _ _ _ _

STANLEY KUBRICK

One of the most revered filmmakers in the history of cinema, Stanley Kubrick achieved legendary status early on. A writer-director renowned for his exacting approach to every element of a film, from the detailed process of writing a screenplay to ensuring every aspect of a film's publicity was to his specifications, Kubrick was also a visionary, whose portrayal of worlds past, present and future were breathtaking in their scope and ambition.

Kubrick directed just thirteen features – including his subsequently disowned debut *Fear and Desire* (1953) – over the course of forty-five years. Except for *Spartacus* (1960), for which he came on board as a replacement director, all were conceived by him. The films do not fit into any single category or genre, save for being studies of humanity in extremis. His portraits of war, *Paths of Glory* (1957) and *Full Metal Jacket* (1987) are bitingly satirical and despairing. His costume drama *Barry Lyndon* (1975) details the adventures of an ambitious rogue, only to end as a compassionate portrait of regret and loss. His vision of the future in *2001: A Space Odyssey* (1968) is epic in scope while refusing an easy interpretation, while *A Clockwork Orange* (1972) is relentless in violence, both personal and societal, which has lost none of its power to shock. And with his takes on Vladimir Nabokov's *Lolita* (1962) and Stephen King's *The Shining* (1980), Kubrick made the material his own, his adaptations veering away from their source as the filmmaker sought to create his own vision of those worlds. He ended with *Eyes Wide Shut* (1999), an exploration of trust and infidelity in marriage. The film's precision and – as always – sly humour, showed for a final time Kubrick to be a master of the medium.

Jack Nicholson in *The Shining*

A PLACE FOR EVERYONE

Kubrick's final film *Eyes Wide Shut* examines one couple's attitude to fidelity. In an early scene, Tom Cruise's character declares that he doesn't feel jealousy towards his wife's suitors, as women are more inclined to fidelity.

In the grid below, can you recreate the character's restrictive view by pairing up characters and sealing off each pair? To do so, place circles and triangles into some squares so that every bold-lined region contains exactly one circle and exactly one triangle. Two identical shapes cannot be in touching grid squares – not even diagonally. No more than one symbol may be placed per square.

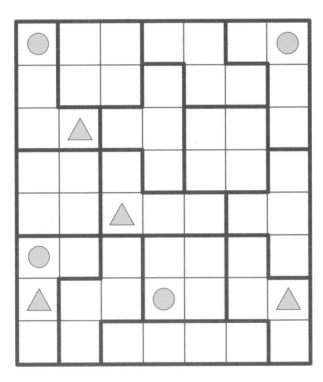

RADICAL WAVES

In the decades following the Second World War, a series of movements, or waves, unfurled throughout world cinema that would have an indelible impact on the way that films were made.

They began with Italian neorealism. Rebelling against the middle-class films made during Benito Mussolini's time in power, films like *Rome, Open City* (1945) and *Bicycle Thieves* (1948) focused on the country's impoverished working class, often featured non-professional actors and were mostly filmed on location. The movement may have lasted less than a decade, but its influence can be felt through subsequent generations. It had a direct impact on parallel cinema in India, best exemplified by *Pather Panchali* (1955), *Aparajito* (1956) and *The World of Apu* (1959), Satyajit Ray's trilogy of films focusing on the life of one character from a small poverty-stricken village.

By far the most influential film movement was the French New Wave, led by a group of critics-turned-directors that included François Truffaut, Jean-Luc Godard, Claude Chabrol and Agnès Varda, a gifted outlier whose experimentations began some years before her male peers. They challenged the French studio system with films shot on location that were indebted to Hollywood, but also attempted to rewrite film language through a different style of shooting, editing and performance. They would inspire equally seismic movements of filmmakers in Japan, led by Nagisa Oshima, in Poland, with the work of Andrzej Wajda and Roman Polanski, and the Czech New Wave. Each drew on the influence of earlier movements, as well as their own cultural history, and influenced other movements over subsequent decades.

Jean-Luc Godard and François Truffaut in conversation

MIXED MOVEMENTS

Jumbled up below are the names of six different cinematic eras, five of which have a geographical element to their name. Can you unscramble the six movements, and then match each to one of the given film and director pairs which typifies that movement?

1. **EXAMINES MORE SPRINGS** (6, 13)

2. **EVER FAWN WENCH** (6, 3, 4)

3. **WOODENLY HOWL** (3, 9)

4. **MENIAL REALISATION** (7, 10)

5. **MURAL RISES** (10)

6. **WHEN WIT IS BRAVE** (7, 3, 4)

A. *Jules and Jim* (1962), **François Truffaut**

B. *Metropolis* (1927), **Fritz Lang**

C. *Rome, Open City* (1945), **Roberto Rossellini**

D. *Taxi Driver* (1976), **Martin Scorsese**

E. *Tom Jones* (1963), **Tony Richardson**

F. *Un Chien Andalou* (1929), **Luis Buñuel**

- -

RADICAL WAVE TRIVIA

1. Milos Forman won two Best Director Oscars, for *One Flew Over the Cuckoo's Nest* (1975) and which musically themed 1984 biopic?

2. Wim Wenders made a 1985 Cannes-winning film set in the US but with a French city in its title. What is the name of the film?

3. What 1968 satire by British Lindsay Anderson was based on his own experiences at public school and is now seen as one of the great anti-establishment films?

4. What is the title of the great 1947 post-war Italian film that sees a man desperate for work unable to carry out his new job because his mode of transport has been stolen?

5. Bram Stoker's family tried to have every copy of which 1922 German horror film destroyed, even though it wasn't named after the author's most famous novel?

WERNER HERZOG

Cinema's answer to the pioneering European adventurers of old, Werner Herzog's prolific feature and documentary output represents the work of an artist of boundless curiosity, but also one with an iron will to present his own vision of the world. He has explored the deepest jungles and most barren deserts in his exploration of humanity's relationship with the world. And along the way, he has produced a handful of masterpieces.

Herzog was a decade into his career when he made his breakthrough feature, *Aguirre, the Wrath of God* (1972). It was the first of five collaborations with lead actor Klaus Kinski – including the epic *Fitzcarraldo* (1982) – and a working relationship that was as combustible as it was fruitful. (That relationship was documented by Herzog in his 1999 film *My Best Fiend*.) *Aguirre* set the standard for so many of his films, travelling deep into the Amazonian jungle to create moments of indelible beauty. The films produced from this collaboration represent the highpoint of Herzog's fiction work. But this is a fraction of his output.

Herzog's documentaries have also seen him travel the world. And his pictorial sensibility has often been strongest in the non-fiction form. Like his narrative features, Herzog found himself drawn to extreme figures, whether it is the elderly deaf and blind woman in *Land of Silence and Darkness* (1971), a man who refuses to leave the slopes of a volcano in *La Soufrière* (1977), or Timothy Treadwell, the subject of *Grizzly Man* (2005), who was obsessed with, and died at, the hands of brown bears in Alaska. And with films like *Fata Morgana* (1971), *Lessons of Darkness* (1992) and *The Wild Blue Yonder* (2005), Herzog even succeeded in presenting Earth as a strange, otherworldly place.

Werner Herzog while filming
Rescue Dawn (2006)

TRAVELLING STORIES

Imagine you are planning out routes to travel between Werner Herzog's various locations for shooting feature and documentary films. On the map below, each circled number represents a location that has the given number of connections made to it.

Join circled numbers with horizontal or vertical lines. Each number must have as many lines connected to it as specified by its value. No more than two lines may join any pair of numbers, and no lines may cross. The finished layout must connect all numbers, so you can travel between any pair of numbers by following one or more lines.

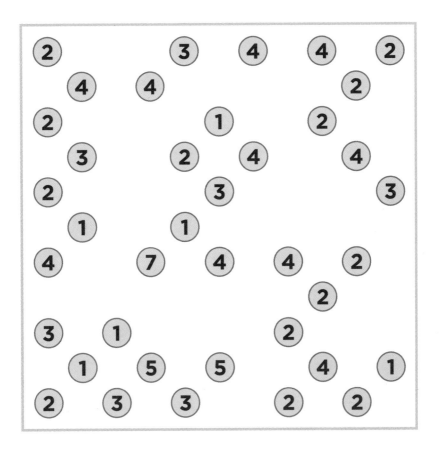

JEAN-LUC GODARD

Among the French New Wave filmmakers, Jean-Luc Godard earned the title of enfant terrible right from the outset. Outspoken, philosophical, confrontational and brilliant, he arrived with a debut that was extraordinarily confident, and that tore up the textbook of classical cinema.

Breathless (1960) was nothing short of a revolution in film. Employing a storyline straight out of a Hollywood crime B-movie, it featured Jean-Paul Belmondo as a con on the run after killing a cop, who attempts to escape with his American girlfriend (Jean Seberg) but whose fate has been sealed. But the way Godard shot and edited the film was anything but conventional. He used a wheelchair for tracking camera shots, mostly employed natural light and when it came to editing, revelled in the use of the jump-cut, breaking up the linearity of a scene and drawing audiences' attention to cuts between shots rather than making them invisible.

Godard then embarked on a decade of industrious activity. By 1967 he had directed fifteen features, multiple shorts and segments of portmanteau films. Some, like *Une femme est une femme* (1961), *Vivre sa vie* (1962), *Le mépris* (1963) and *Bande à part* (1964) were aligned with the French New Wave, while later films such as *Pierrot le fou* (1965), *La Chinoise* and *Weekend* (both 1967) were increasingly political – a direction that would come to dominate his work over the next decade. He continued to work for the rest of his life, producing his last film, *The Image Book*, in 2018. His influence has been monumental – contemporary cinema would not be the same without him.

Brigitte Bardot and Michel Piccoli in *Le mépris*

VISIBLE CUTS

Several pieces of information about one of Godard's most famous films have been cut up and left on the 'cutting room floor' below. Can you piece these fragments back together to reveal the details that have been replaced by underlines beneath?

Any spaces between words have been removed within the fragments.

ANG	**BRI**	**CON**	**DOT**
DYS	**EBAR**	**FRI**	**GITT**
ITA	**LY**	**PT**	**SEY**
TEM	**THEO**	**TZL**	

Film title: _____

Lead actor: _____

Location: _____

Director/actor: _____

Meta-film: _____

- -

NEW WAVE TRIVIA

Divide the following films between those directed by either Jean-Luc Godard or François Truffaut:

The 400 Blows (1959)
Breathless (1960)
Shoot the Pianist (1960)

Alphaville (1965)
Pierrot le Fou (1965)
Fahrenheit 451 (1966)
Made in U.S.A (1966)
Weekend (1967)
The Bride Wore Black (1968)
Day for Night (1973)

ANTONIONI AND FELLINI

Two Italian directors dominated the 1960 Cannes Film Festival. Each was there with a film that would prove a significant landmark in their career. Federico Fellini won the top prize, the Palme d'Or, for his satire of contemporary Roman life, *La Dolce Vita*. Michelangelo Antonioni was awarded the Jury Prize for *L'Avventura*, a portrait of bourgeois disaffection revolving around a group of friends visiting an island and one of them going missing. These directors' styles could not be more different. One was carnivalesque, the other coolly detached. But their success denoted a major moment in Italian cinema.

Both filmmakers emerged in the 1940s and were inspired by the neorealist movement. Fellini's directorial style would soon embark on its own unique path, becoming more boisterous, as seen in the early films *The White Sheik* (1952), the semi-autobiographical *I Vitelloni* (1953) and *Nights of Cabiria* (1957), which would be remade as the stage and screen musical *Sweet Charity* (1969). Fellini

followed *La Dolce Vita* with *8½* (1963), one of the great films about filmmaking. Other films included *Fellini Satyricon* (1969), the autobiographical *Amarcord* (1973) and *Ginger and Fred* (1986), the last film to star his two longstanding on-screen collaborators – his wife Giulietta Masina and alter-ego Marcello Mastroianni.

Antonioni had filmed a series of dramas dealing with social alienation throughout the 1950s, but the style of *L'Avventura* was a breakthrough for him. The two films that followed, *La Notte* (1961) and *L'Eclisse* (1962) made up a loose trilogy portraying disaffection among the Italian middle classes. If the subsequent *Red Desert* (1964) was a radical experiment in colour, *Blow-Up* (1996), his first English language film, captured the spirit of 1960s London. He would fare less well with US counterculture in *Zabriskie Point* (1970), but the Jack Nicholson drama *The Passenger* (1975) would prove to be his final masterpiece.

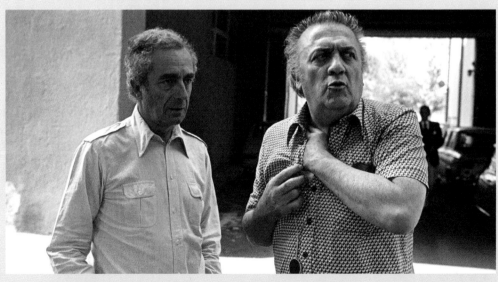

Michelangelo Antonioni (left) and Federico Fellini (right)

THE SWEET LIFE

La Dolce Vita follows the character of Marcello as he travels through Rome over the course of seven days and nights. Several iconic landmarks – such as the Trevi fountain and St Peter's Basilica – appear throughout the film's unfolding narrative. Can you similarly find your way through the maze of streets below,

from the entrance at the top to the exit at the bottom, without going back on yourself?

Your route will pass over several numbers: read them in the order they are encountered to reveal the number of tickets sold for *La Dolce Vita* in Italy during its release.

INGMAR BERGMAN

The Swedish director Ingmar Bergman is synonymous with art film. In a directing career that spanned six decades, he was responsible for some of the starkest visions of human existence. Born in 1918 and into a Lutheran family, Bergman claimed to lose his faith aged eight, a theme he would return to later in his work. He studied art and literature at Stockholm University but spent much of his time in student theatre. It was during this period that he became fascinated by cinema.

His film career began in 1944, when he wrote the script for the film *Torment*, a coruscating and controversial portrait of the country's education system. His first film as a director was *Crisis* (1946), but it was his twelfth feature, the frank, youthful relationship drama *Summer with Monika* (1953), that brought him international attention. He followed its success with *Smiles of a Summer Night* (1955) and two landmark films in 1957: *The Seventh Seal* and *Wild Strawberries*. This tale of a knight in medieval Europe and a road movie featuring an ageing academic looking back on his life,

cemented Bergman's reputation as one of European cinema's most formidable talents.

After further success with *The Virgin Spring* (1960) and challenging audiences with the stark existential trilogy comprising *Through a Glass Darkly* (1961), *Winter Light* and *The Silence* (both 1963), Bergman made one of his boldest films with *Persona* (1966), a psychosexual drama now regarded as the apex of arthouse cinema. He would continue to plumb the darkest recesses of human emotions and relationships over the course of the next forty years, which included the touching, semi-autobiographical and multiple Oscar-winning *Fanny and Alexander* (1982). His final film, *Saraband* (2003), a response of sorts to his excoriating 1974 film *Scenes From a Marriage*, was a fitting end to an extraordinary career.

Max von Sydow's knight attempts to cheat death in *The Seventh Seal*

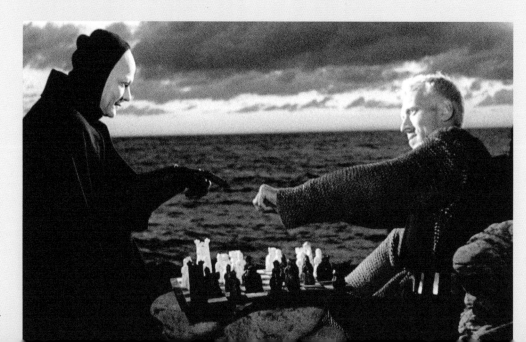

KNIGHT'S MOVE

Bergman's *The Seventh Seal* features a game of chess, played by the film's protagonist and the personification of death. Can you use your skills of logic and deduction to beat your opponent – time itself – in the grid below? Simply place a digit from 1 to 9 into each empty square, so no digit repeats in any row, column or bold-lined 3×3 box. Also, no pair of identical digits may be exactly a knight's move in chess apart from one another (that is, one across and two down – or two across and one down).

NEW GENERATIONS

By the late 1960s, classical Hollywood cinema, dominant since the 1930s, was in its death knell. Society had changed significantly, but the moral code that determined the kinds of films people saw remained mostly unchanged. A new generation of directors was emerging, who would transform American cinema in the 1970s.

Influenced by the French New Wave, New Hollywood filmmakers like Robert Altman, Martin Scorsese, Barbara Loden, Hal Ashby, Francis Ford Coppola, George Lucas, Brian De Palma and Steven Spielberg led a decade in which the studio bowed to the influence of the director. If *Easy Rider* (1969), with its portrait of a divided America, led the way, countless films followed that would create another, albeit different, golden age in American film. Alongside high-profile films such as *The Godfather* (1972), *Jaws* and *Nashville* (both 1975), there were more low-key but no less rewarding dramas such

as *Wanda*, *Five Easy Pieces* (both 1970), *Harold and Maude* (1971) and *Mean Streets* (1973). These would go on to influence new generations of filmmakers.

At the same time, the New German Cinema saw a similar rebellion against the status quo, led by Rainer Werner Fassbinder, Wim Wenders and Werner Herzog. Other movements unfolded in middle Eastern and Asian countries from the 1970s through to the early 1990s. In Denmark towards the end of the 1990s, Lars von Trier and his filmmaking peers created the Dogme Manifesto, which challenged filmmakers by restricting their use of artifice. While in the early 2000s, the first generation of post-Nicolae Ceaușescu filmmakers put Romanian cinema on the filmmaking map, thanks to the Cannes success of *4 Months, 3 Weeks and 2 Days* (2007).

Brian De Palma (left), Steven Spielberg (centre) and Martin Scorsese

LAUDED LEGENDS

Each of the named directors below is associated with new movements in cinema. Can you fit all of their surnames into the grid once each, writing one letter per box? When complete, the letters in shaded squares can be rearranged to spell out the name of an actor associated with New Hollywood. Who is it?

4 letters
Penn

5 letters
Allen
Ashby
Loden
Lucas
Lumet
Palma
Trier

6 letters
Altman
Brooks
Forman
Herzog
Hopper
Romero

7 letters
Boorman
Coppola
Kubrick
Nichols
Wenders

8 letters
Friedkin
Rafelson
Scorsese

9 letters
Rosenberg
Spielberg

10 letters
Fassbinder

MARTIN SCORSESE

One of the key figures of the New Hollywood, Martin Scorsese quickly established himself as a leading filmmaker of his generation. His work often features protagonists grappling with their beliefs or spirituality, whether it is a boxer tormented by demons, religious figures plagued by doubts or mobsters grappling with their actions.

After a series of successful shorts, work as an editor on the era-defining concert film *Woodstock* (1970) and directing two features, *Who's That Knocking at My Door* (1967) and *Boxcar Bertha* (1972), Scorsese achieved critical and commercial success with *Mean Streets* (1973), a powerful portrait of young Italian American lives in New York's Little Italy. His fluid direction, evocative use of music and deconstruction of masculine tropes would become defining characteristics of his work. It also marked the beginning of the

filmmaker's collaboration with Robert De Niro. They worked together on *Taxi Driver* (1976) one of the high points of 1970s cinema, followed by the gritty musical *New York, New York* (1977), the masterful *Raging Bull* (1980) and more recently *The Irishman* (2019) and *Killers of the Flower Moon* (2023).

Scorsese's films over the course of fifty years are impressively diverse but defined by their intensity, from *The King of Comedy* (1982), *The Last Temptation of Christ* (1988), *Goodfellas* (1990) and *The Age of Innocence* (1993) to *Kundun* (1997), the multiple Oscar-winning *The Departed* (2006), *Hugo* (2011), *The Wolf of Wall Street* (2013) and *Silence* (2016). Working mostly with editor Thelma Schoonmaker, he has created a body of work that ranks him among the greatest filmmakers – a master of his craft and a champion of the medium he adores.

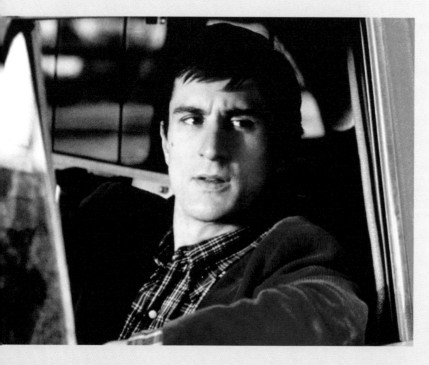

Robert De Niro as Travis Bickle in *Taxi Driver*

FREEZE FRAME

Scorsese's films are well known for their use of 'freeze frames' – stopping the action to allow the narration to momentarily dominate the storytelling.

Each of the 'freeze frames' below depicts one of Scorsese's frequent collaborators, Robert De Niro. For each image, can you say which Scorsese film it is taken from?

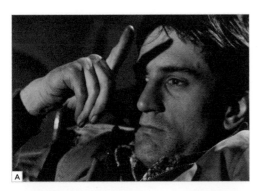

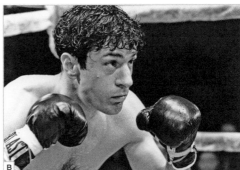

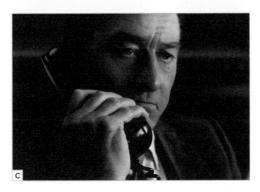

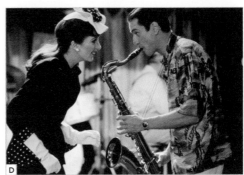

A _____

B _____

C _____

D _____

STEVEN SPIELBERG

There are few filmmaker names that most people recognize. Steven Spielberg would definitely make that list. He is the most famous successful filmmaker in cinema history and the perfect combination of entertainer and artist.

After an early start making low-budget films at home, Spielberg became the youngest director to sign a long-term contract with a major Hollywood studio. He shot a pilot episode of a series with legendary star Joan Crawford, who was one of the first people to recognize his innate gifts. His 1971 TV movie *Duel* was so impressive it received a theatrical release. But it was *Jaws* (1975) that cemented his reputation. He turned a pulpy sea-bound thriller into a first-class entertainment that exuded wit, intelligence and – the many technical hitches during the shoot notwithstanding – bravura filmmaking. Over the next 15 years he would entertain with *Close Encounters of the Third Kind* (1977), the *Indiana Jones* series, *E.T. the Extra-Terrestrial* (1982) and *Jurassic Park* (1993). At the same time, he branched into more serious filmmaking with *The Color Purple* (1985), *Empire of the Sun* (1987), and Oscar winners *Schindler's List* (1993) and *Saving Private Ryan* (1998). Each is a technical marvel. And many, including subsequent films such as *Catch Me If You Can* (2002), *War of the Worlds* (2005) and *Ready Player One* (2018), deal with dysfunctional families and absent fathers, themes that would become manifest in the filmmaker's semi-autobiographical cinematic memoir *The Fabelmans* (2022).

A MAN OF MANY TALENTS: SPIELBERG FILMS

Listed below are the names of various films directed, written or produced by Steven Spielberg, or in which he made a cameo appearance of some kind. Can you fit them all into the grid, crossword-style, with one letter per box? Once complete, the movies in shaded boxes will identify those films in which he was involved exclusively as a director.

3 letters
DAD

4 letters
DUEL
HOOK
JAWS
PAUL

5 letters
BALTO

6 letters
ALWAYS
AMBLIN
CASPER
MUNICH
THE BFG

7 letters
AMISTAD
LINCOLN
TWISTER

8 letters
GREMLINS

9 letters
FIRELIGHT

10 letters
INNER SPACE
MEN IN BLACK

PEDRO ALMODÓVAR

Spain's most famous filmmaker, Pedro Almodóvar's adoration of melodrama, embrace of kitsch and considerable skills as a writer and director have seen his films' popularity extend far beyond the boundaries of his homeland. They might occasionally wear the influence of earlier filmmakers, such as Alfred Hitchcock, Douglas Sirk and New German Cinema icon Rainer Werner Fassbinder, but in their bold visual style and often dazzlingly labyrinthine narrative construction, they could not be mistaken for any other filmmaker.

Almodóvar was part of the La Movida Madrileña, a major cultural movement that emerged during Spain's transition to democracy in the late 1970s. Early work such as *Pepi, Luci, Bom* (1980), *Dark Habit*s (1983) and *Matador* (1986) embraced the sexual and political freedom the country now enjoyed. Many featured and made a star out of Antonio Banderas. With *Women on the Verge of a*

Nervous Breakdown (1988), Almodóvar scored his first major international success. It also identified him as a filmmaker who mostly focused on female characters.

A defining characteristic of Almodóvar's cinema is his bold, often expressionistic use of colour. In films like *High Heels* (1991) and *Broken Embraces* (2009), he uses it to extraordinary effect. While Oscar-winning dramas *All About My Mother* (1999) and *Talk to Her* (2002) highlight his ingenuity as a screenwriter. Alongside Banderas, Almodóvar has worked with some of the finest Spanish female stars, most notably Penélope Cruz, who has been one of his key actors since playing a cameo in *Live Flesh* (1997). She dazzles in *Volver* (2006), *Broken Embraces* and *Parallel Mothers* (2021), films that have cemented Almodóvar's reputation as a singular figure on the landscape of film.

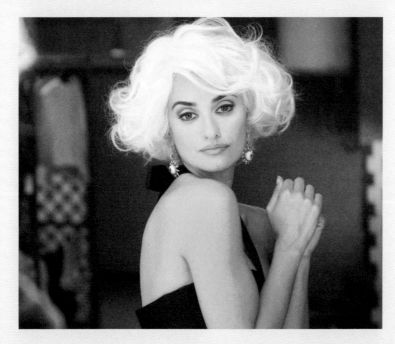

Penélope Cruz in
Broken Embraces

A WORLD OF COLOUR

Almodóvar is famous for his bold use of colour – perhaps most of all, red. On each line below, the name of a film has been blended with the name of a colour, which will be a shade of green, blue, red or yellow. Separate out the film and the colour, then match each pair to one of the images based on the colour you have uncovered, to reveal which movie each still is taken from. Spaces have been ignored.

1. STAALPKPTHOIHERER

2. ALVLAEBOURTMMIYLMOTIHOENR

3. EMVEORLAVLEDR

4. JLULEIMEOTNA

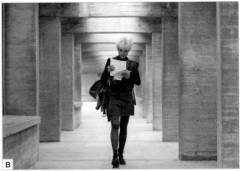

SPIKE LEE

One of the most vital contemporary filmmakers, Spike Lee has been instrumental in portraying the Black experience in the United States, both through his acclaimed narrative features and his expansive documentary work. Alongside Martin Scorsese and Sidney Lumet, Lee is one of the filmmakers most closely associated with screen representations of New York City, although his full body of work encompasses the wider United States and occasionally travels further afield.

After graduating from New York University's Tisch School of the Arts, Lee scored a modest success with his debut *She's Gotta Have It* (1986), a comedy drama about a young woman with three male lovers. The film earned critical acclaim for steering clear of lazy racial stereotypes. But it was the filmmaker's incendiary 1989 release *Do the Right Thing* that established his reputation. A blistering account of racial intolerance within a multicultural Brooklyn community, its uncompromising politics and narrative style, bold use of colour and Public Enemy's music,

and mastery over rhythm and tone marked it out as one of the key US films of the era.

In 1992, Lee released one of his most accomplished films, the epic biopic *Malcolm X* (1992). It starred Denzel Washington, who also appears in the filmmaker's *Mo' Better Blues* (1990), *He Got Game* (1998) and *Inside Man* (2006). Subsequent notable films Lee made the 1990s and 2000s include the urban crime thriller *Clockers* (1995), *Summer of Sam* (1999), a multi-narrative portrait of 1970s New York, the media satire *Bamboozled* (2000), post-9/11 New York drama *25th Hour* (2002) and anti-gang musical *Chi-Raq* (2015). *BlacKkKlansman* (2018) finally saw Lee win an Oscar, for Best Adapted Screenplay. He followed it with one of his most ambitious dramas, *Da 5 Bloods* (2020), which dealt with the impact of the Vietnam conflict on the Black soldiers who fought in it.

Spike Lee, Danny Aiello, Richard Edson and John Turturro in *Do the Right Thing*

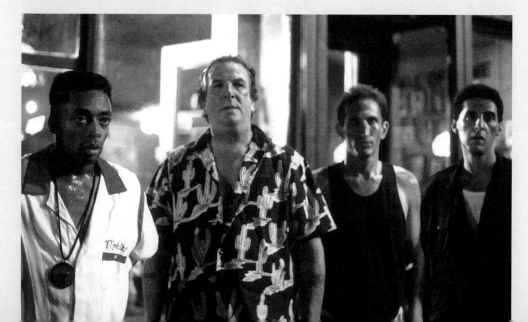

HIDING IN PLAIN SIGHT

Lee's film *BlacKkKlansman* is based on the true story of Ron Stallworth, a black police officer who posed as a member of the Ku Klux Klan while working undercover. The name 'Ron' is itself hidden undercover in the grid below, appearing exactly once – although it may be written in any direction. Can you find it?

KATHRYN BIGELOW

Challenging the notion that action cinema is the domain of male filmmakers, Kathryn Bigelow has crafted a body of work that intelligently grapples with the trappings of genre cinema, while exploring the representation of gender and violence on the screen.

Trained as a painter, Bigelow's first film was the short *The Set-Up* (1978), a deconstruction of violence in film. She followed it with her feature debut, the biker drama *The Loveless* (1981). But her breakthrough came with her revisionist vampire thriller, *Near Dark* (1987). It saw her play with genre conventions for the first time, which she continued to do with the triller *Blue Steel* (1990), starring Jamie Lee Curtis as a cop pursued by a psychotic killer. The cult hit *Point Break* (1991) pushed the conventions of the buddy movie to its limit, turning cliches about masculinity on their head while delivering a kinetic, technically impressive action thriller. Bigelow then went further with the visionary, controversial *Strange Days* (1995). A fin-de-siecle LA-set thriller, the film is a technical tour-de-force whose graphic imagery is justified by the filmmaker's probing intelligence and questioning our acceptance of screen violence as 'entertainment'.

The 2000s saw a change in gear. Working with the journalist-turned-screenwriter Mark Boal, Bigelow directed three films located within a real-world scenario. *The Hurt Locker* (2008) details the pressures faced by a US Army explosive ordnance disposal team in Iraq and saw her become the first woman to win a Best Director Oscar. The controversial *Zero Dark Thirty* (2012) and 1960s drama *Detroit* (2017) followed. Together, they cemented Bigelow's position as one of contemporary cinema's most kinetic filmmakers.

Kathryn Bigelow on the set of *Zero Dark Thirty*

POINT BREAK

In the film *Point Break* (1991), Keanu Reeves' character is charged with locating a group of seemingly untraceable bank robbers. Can you step into his shoes, and try to locate the suspects in the grid below by following the given clues?

Place dots in some empty squares to mark where the suspects are hiding. Clues show the exact number of suspects in touching squares – including diagonally. No more than one suspect may be placed per square, and none of them may share a square with a number.

When complete, count up the total suspects you have found, then multiply that number by five to reveal the total number of skydives actor Patrick Swayze is said to have made for the film – although he only did so after principal photography was complete, to replace previously filmed stunt photography.

1			2		1
1		3		4	
	2			4	
	2		3		2
		2	4		3
1	2		2		

QUENTIN TARANTINO

Few filmmakers from the last thirty years have had as significant an impact on cinema as Tarantino. Blurring the line between high and low culture, drawing on a vast and impressive range of cinematic, literary and cultural references, creating indelible characters and set pieces, all played out on a visually striking landscape, Tarantino created a cinematic jukebox that was, by turns, playful, abrasive, violent and, for the most part, fun.

Tarantino hit the ground running with his accomplished debut *Reservoir Dogs* (1992). A tale of a bank robbery gone awry, seen from the perspective of the perps and shifting back and forth in time, the film showcased his ear for a memorable line, his direction of actors and impressive knowledge of 1970s pop classics. *Pulp Fiction* (1994), with its three intersecting, non-linear narratives, unfolding in the world of hoodlums and fixed sports matches, went further. A winner at both Cannes Film Festival and the Oscars,

it cemented Tarantino's reputation as the king of pop culture. *Jackie Brown* (1997), an adaptation of Elmore Leonard's crime novel *Rum Punch*, was the filmmaker's most overt homage to his beloved 1970s Blaxploitation films, while the two volumes of *Kill Bill* (2003–04) paid respect to Tarantino's love of Asian martial arts films.

With the bloody Second World War adventure *Inglourious Basterds* (2009), Tarantino embraced revisionist history. *Django Unchained* (2012) embraced elements of the spaghetti western for a blistering portrait of slavery in the Deep South before the American Civil War, while *The Hateful Eight* (2015) offered up a wintery take on the genre. And *Once Upon a Time in Hollywood* (2019) – now a novel and film by Tarantino – recalibrated the Charles Manson killings through the prism of a TV star's dwindling career.

Quentin Tarantino on the set of *Inglourious Basterds*

THE REPERTORY

On each line below is the jumbled name of an actor who has appeared in a prominent role in one of Tarantino's films. Each name, in addition, has had one letter added to it which, when extracted from the rest and read in order from top to bottom, reveals the name of a final frequent collaborator. Who is it?

1. **BLOODIER PANIC ROAD** (8, 8)

2. **JUNK MORAL SCALES** (6, 1, 7)

3. **SULK RAT RULES** (4, 7)

4. **DART SPLOTCH WHIZ** (9, 5)

5. **HUMAN PUT ARM** (3, 7)

6. **HOT JOVIAL RANT** (4, 8)

7. **I CULL TUY** (4, 3)

8. **JAM FOX EXIT** (5, 4)

1. _ _ _ _ _ _ _ _ _ _ _ _ _ _ _ _

2. _ _ _ _ _ _ _ _ _ _ _ _ _ _

3. _ _ _ _ _ _ _ _ _ _ _

4. _ _ _ _ _ _ _ _ _ _ _ _ _ _

5. _ _ _ _ _ _ _ _ _ _

6. _ _ _ _ _ _ _ _ _ _ _ _

7. _ _ _ _ _ _ _

8. _ _ _ _ _ _ _ _ _

PARK CHAN-WOOK

A filmmaker whose labyrinthine narratives unfold in a moral penumbra, with a visual style that evinces a sheen that contrasts with the violence of both his characters and their emotions, Park Chan-wook is one of the most gifted of a new generation of Korean filmmakers – a festival favourite whose work has immense international appeal.

It was with Park's third film, *Joint Security Area* (2000), a thriller about an investigation into a killing in the no-man's land between North and South Korea that he established his reputation domestically. But it was his *Vengeance* trilogy, mystery crime thrillers that unfold in a morally vacuous world, comprising *Sympathy for Mr. Vengeance* (2002), *Oldboy* (2003) and *Lady Vengeance* (2005), that introduced Park to international audiences. *Oldboy*, in particular – an award winner at the Cannes Film Festival – found a sizeable cult audience.

After the eccentric and enjoyable *I'm a Cyborg, But That's OK* (2006), Park revelled in vampire lore with his startlingly graphic and original *Thirst* (2009), which melded Catholic guilt with sexual desire in its loose adaptation of French writer Émile Zola's 1868 novel *Thérèse Raquin*. He followed it with his only English-language feature, the Deep South gothic thriller *Stoker* (2013). Park's most recent films have proven his most successful among international audiences. With *The Handmaiden* (2016) he relocated Sarah Waters' novel *Fingersmith* from Victorian England to Korea under Japanese colonial rule. And *Decision to Leave* (2022) is a modern-day noir in which the atmospherics, expertly conceived narrative and rapturous visuals have become signature elements of this gifted filmmaker's work.

Park Chan-wook on the set of *The Handmaiden*

DOUBLE CROSSED

The Handmaiden makes clever use of flashbacks to reveal the overlapping ulterior motives of the main characters – with multiple betrayals, and the occasional act of double-crossing, as a result.

In the grid below, can you use preventative tactics to stop more than four of these 'crossings' happening in a row? Place either an 'X' or an 'O' into each empty square so that no lines of four or more 'X's or 'O's are formed in any direction, including diagonally.

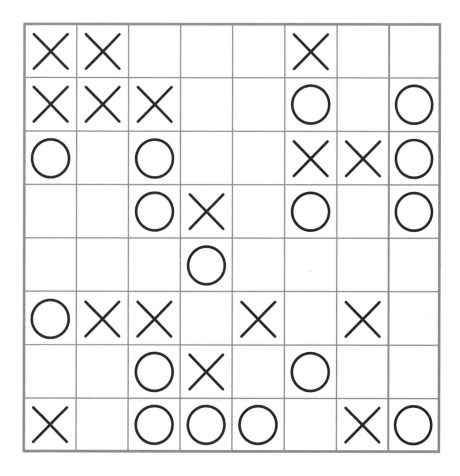

CÉLINE SCIAMMA

Over the course of just five features, Céline Sciamma has established herself as one of this century's most preeminent European filmmakers. The simplicity of her narratives belies her great skill in directing actors and reaching to the heart of her subject. This was in evidence in her feature debut, *Water Lillies* (2007), about the sexual awakening of three teenage girls in a middle-class Paris suburb.

A grittier take on teenage life dominates *Girlhood* (2014), which focuses on the troubles faced by a young Black girl in a rough Parisian neighbourhood. More stylized than her debut, the film was also a striking contrast to her second feature, *Tomboy* (2011). Like the films that bookend it, *Tomboy* unfolds over the course of a summer as it follows a ten-year-old girl who has moved into a new neighbourhood with her family. Over the school holidays she

passes herself off as a boy. Avoiding sensation, Sciamma instead presents a moving portrait of a child grappling with their identity.

It was with the award-winning *Portrait of a Lady on Fire* (2019) that Sciamma cemented her international standing. Set towards the end of the eighteenth century, it details the growing intimacy between a young aristocrat and the artist commissioned to paint her. Sciamma makes the most of the barren rural landscape to contrast with the protagonist's torrent of emotions. She followed it with *Petite Maman* (2021), a slither of a drama about a young girl encountering her mother as a young girl, following the death of her grandmother. A sensitive portrait of childhood and grief, it further enhanced Sciamma's critical standing.

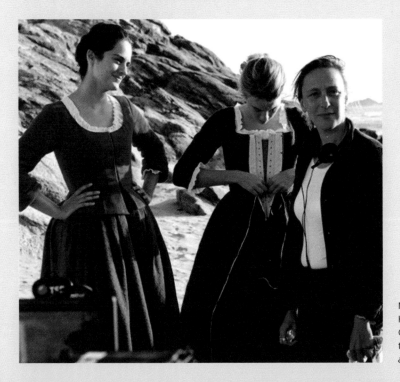

Noémie Merlant, Adèle Haenel and director Céline Sciamma on the set of *Portrait of a Lady on Fire*

HIDDEN TALENT

Sciamma's films are notable for her casting of performers who have never previously acted. In *Girlhood*, for example, the film's lead character was scouted by the casting crew on the streets of Paris. Can you use your logical skills to reveal the name of the hidden talent?

Place each of the letters A, D, E, I, J, K, O, P, R, S, T and U once each into every row, column and bold-lined 4×3 box. When complete, the name of the lead actor in *Girlhood* will be revealed along the shaded diagonal (7, 5).

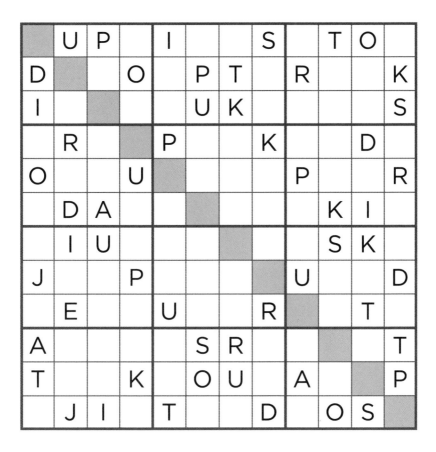

CHRISTOPHER NOLAN

Few filmmakers display such an obsession with time as Christopher Nolan. From his striking, ultra-low-budget debut *Following* (2018), Nolan's films have consistently played with temporal structure, often unfolding in fragmented form, or existing within a world where time is malleable. Nolan has become a leading filmmaker of the twenty-first century, whose big-budget Hollywood productions are notable for intelligence and ingenuity.

Memento (2000), Nolan's second film and commercial breakthrough, highlighted his bold narrative and visual style. The story of a man with anterograde amnesia hunting down the killers of his wife, the black-and-white scenes play out chronologically, while the colour sequences play in reverse order. This extreme play with time and linearity would reach its apotheosis with his global espionage thriller *Tenet* (2020), which combines the pyrotechnics of a blockbuster with the narrative conundrum of a Jorge Luis Borges tale.

After the relative linearity of the taut, confidently directed cop thriller *Insomnia* (2002), Nolan journeyed into the world of DC and their most troubling hero, Batman. The *Dark Knight* trilogy (2005–12) brought Nolan international acclaim, with *The Dark Knight* (2008) significantly raising the bar for the genre. Between these films he directed *The Prestige* (2006), an atmospheric Victorian-era tale of two magicians competing with each other to the death and *Interstellar* (2014), a dazzling exploration through space and time.

Dunkirk (2017) brought Nolan further acclaim. Its account of the famous event from the Second World War is seen from the perspective of British soldiers evacuating the French beach, a fishing trawler skipper journeying there to help bring soldiers home and a Spitfire pilot. Once again, it employs a fragmented time structure to impressive effect. Nolan returned to this era for *Oppenheimer* (2023), his monochrome portrait of the scientist and the first atomic bomb tests.

A NUMBERS GAME

Can you use your mathematical skills to solve each of these number chains and reveal more information about Nolan's films? Starting with the number on the left, perform each of the mathematical operations in turn from left to right. In the final, empty box, write in the resulting number to reveal the solution to the clue given above each number chain.

1. **An unspecified date in *Tenet* (2020) around which the plot centres: the _____th**

42	÷ 7	+ 52	÷ 2	- 15	

2. **The number of years that are equivalent to one hour at a key point in *Interstellar* (2014), due to time dilation caused by a black hole**

71	- 32	÷ 3	x 2	- 3	

3. **Bruce Wayne's age when his parents are killed in *Batman Begins* (2005)**

144	÷ 9	x 2	+ 8	÷ 5	

4. **The unusually small number of pages in the script for *Dunkirk* (2017), which Nolan also wrote**

15	÷ 5	x 41	+ 29	÷ 2	

ACTOR-DIRECTORS

The notion of the actor-director is not a recent one. It dates back to the days before feature filmmaking. D.W. Griffith, one of the earliest Hollywood feature directors started out as an actor.

Then there are the great comedians of the pre-sound era, such as Charles Chaplin, Buster Keaton and Roscoe 'Fatty' Arbuckle, who oversaw their greatest work. Other comic performers such as Harold Lloyd and Mabel Normand, handed over the reins for their most famous films, but still had some experience behind the camera. Later comedian-entertainers who impressed as much behind the camera as they did in front include Jerry Lewis and Gene Kelly, whose *Singin' in the Rain* (1952), co-directed with Stanley Donen, frequently ranks as one of the greatest films ever made.

In the case of many actors who take up directing, it is a natural extension in the course of their career, as in the case of John Cassavetes with *Shadows* (1959) and Dennis Hopper with *Easy Rider* (1969), co-directed with fellow actor Peter Fonda. For other actor-directors, including Warren Beatty (*Reds*, 1981), Kevin Costner (*Dances with Wolves*, 1990), Mel Gibson (*Braveheart*, 1995), George Clooney (*Good Night, and Good Luck*, 2005), Ben Affleck (*Argo*, 2012) and Bradley Cooper (*A Star Is Born*, 2018) the turn to directing has proven fruitful come the awards season. While other major figures, from Orson Welles, Woody Allen and Clint Eastwood to Takeshi Kitano, Spike Lee and Agnés Jaoui are as famous for being a director as they are a presence on screen.

There are also the filmmakers who have enjoyed brief cameo screen appearances. They include John Huston, Martin Scorsese and Quentin Tarantino. But none are as famous as the blink-and-you'll-miss-them appearances by Alfred Hitchcock in many of his films.

George Clooney on the set of *Good Night, and Good Luck*

SEEING DOUBLE

For each of the stills below, can you name
the actor-director and the film shown?

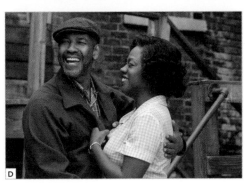

A. Actor-director: _____

Film shown: _____

B. Actor-director: _____

Film shown: _____

C. Actor-director: _____

Film shown: _____

D. Actor-director: _____

Film shown: _____

ACTOR/DIRECTOR PARTNERSHIPS

The collaborative relationship between a star and their director is a mutually conducive partnership – the filmmaker brings all their skills to bear in ensuring that everything is perfect for the actor to deliver their best performance, while the star brings kudos to the director.

The Blue Angel (1930) made a star of Marlene Dietrich. She realized that director Josef von Sternberg knew exactly how to light her and they worked on a further six films together. Classical Hollywood director George Cukor understood Katharine Hepburn's screen appeal and worked with her on ten films, including the hits The Philadelphia Story (1940) and Adam's Rib (1949). Some of those films starred Cary Grant, whose career profited from his eight collaborations – four each – with Howard Hawks and Alfred Hitchcock, including His Girl Friday (1940) and North by Northwest (1959). Hitchcock also worked with James Stewart on four films, including key works Rear Window

(1954) and Vertigo (1958). Stewart also worked on eight films in five years with Anthony Mann. What all these collaborations share is directors who understood how to bring out the best in their actor.

Certain collaborations have helped bolster the careers of both director and star. There is Michelangelo Antonioni and Monica Vitti, Ingmar Bergman and Max von Sydow, Billy Wilder and Jack Lemmon, Tim Burton and Johnny Depp and, most recently, Ryan Coogler and Michael B. Jordan. Then there are those rare relationships that have melded with cinematic legend, creating an iconic screen relationship; whether it's Federico Fellini with Marcello Mastroianni (six films), Martin Scorsese with Robert De Niro (ten films), Yasujirō Ozu with Chishū Ryū (fifty-two films), John Ford with John Wayne (twenty-one films) or Akira Kurosawa with Toshiro Mifune (sixteen films).

Ryan Coogler and Michael B. Jordan on the set of Fruitvale Station (2013)

MAKING LINKS

Each of the eight groups of three films listed below clues an actor and director who collaborated on these titles, among others. Then, in the grid beneath, are various sets of initials, each of which represents either an actor or a director from one of the clued partnerships. After identifying each pair being clued, draw a path to join one circled set of their initials to the other. If paired correctly, you will be able to draw all these paths so that no more than one path enters any square, and they do not cross. Paths must travel only horizontally or vertically between squares.

1. **Hellboy** (2004), **Pan's Labyrinth** (2006), **The Shape of Water** (2017)
2. **Marie Antoinette** (2006), **The Virgin Suicides** (1999), **The Bling Ring** (2013)
3. **Catch Me If You Can** (2002), **The Terminal** (2004), **Bridge of Spies** (2015)
4. **The Irishman** (2019), **Mean Streets** (1973), **Taxi Driver** (1976)
5. **Pulp Fiction** (1994), **Jackie Brown** (1997), **True Romance** (1993)
6. **All About My Mother** (1999), **Volver** (2006), **Broken Embraces** (2009)
7. **The Royal Tenenbaums** (2001), **The Darjeeling Limited** (2007), **The Grand Budapest Hotel** (2014)
8. **Days of Being Wild** (1990), **In the Mood for Love** (2000), **2046** (2004)

	GT		SC					SS
					MS			
				SJ	PA		BM	
DJ								
KD				WK		TH		
WA		PC	MC				RD	
QT								

5

It's a Wrap

When shooting ends, known as a wrap, a film is only partially completed. For many directors, it is during the editing process that a film really begins to take shape.

All the shots are pieced together, with a film editor working with sound editors, mixers and foley artists to realize the director's vision. The visual effects team, if required, adds its work to the mix, and colour graders make sure the look the cinematographer intended is rendered perfectly in the final cut. Composers or music supervisors add the score or chosen pre-recorded tracks in tandem with the editorial team. And the titles designer adds credits at the chosen point in a film. All of these stages are as essential to the film as the work done before and during the shoot. They may seem less glamorous than what takes place on set with actors present, but they are an integral part of the filmmaking process.

Some individuals have become renowned for their work at this stage. Title design, for instance, can create the right atmosphere for a film. In addition to creating some of the most iconic film poster designs, Saul Bass also directed many title sequences, most notably his work with Alfred Hitchcock on *Vertigo* (1958), *North by Northwest* (1959) and *Psycho* (1960). Then there is Maurice Binder, whose designs for the opening sequences for most of the Bond films from *Dr. No* (1962) to *Licence to Kill* (1989), would prove hugely influential. But before the titles are added, there is the edit.

THE EDIT

Editing can collapse space and time. It allows us to travel with a character from one place to another without having to see their whole journey. It enables us to watch a series of events taking place simultaneously. It gives the illusion of events all happening within the same space when a shoot might employ multiple locations. And it is a technical operation that allows for an enormous amount of creativity.

At the most basic level, an editor takes a series of shots and splices them together in a specific order to create a sequence or scene. Each of those are then joined together to create the whole film. For the early decades of cinema, a classical style of editing – called continuity editing – dominated mainstream cinema, whereby the cuts employed in a film created a logical sense of space for the viewer. Experimental films were more playful in how they disrupted this sense of space. After the Second World War, with the arrival of movements like the French New Wave, more radical approaches to editing became commonplace.

Editing in the celluloid era was a very physical role. Editors used a work print to piece a film together manually. The arrival of digital technology meant that films could be pieced together in a less cumbersome way. In some cases, a filmmaker may edit their own work. If they did not, they would still be a presence in the editing suite, ensuring that the editor is piecing a film together in the way they envisioned it. The first cut – a rough cut – of a film may be longer than the final version. Like a sculptor, the editor will 'chip' away, removing scenes or cutting them down, until the film is at its desired length or achieves what the filmmaker intended.

Director François Truffaut looking at a strip of film

CUT TOGETHER

Each of the six films listed below features an ensemble cast of well-known actors. On the six lines to the right, the partial surnames of some of these actors have been spliced together to create one continuous 'cut' of names, joining four names in each ensemble string.

Can you match each of the six films to the ensemble cast 'cut' that it is associated with?

1. *Ocean's Eleven* (2001)

2. *Knives Out* (2019)

3. *Pulp Fiction* (1994)

4. *Much Ado About Nothing* (1993)

5. *Spotlight* (2015)

6. *12 Years a Slave* (2013)

A. **AVOLT-HURMA-WILLIS-ACKSO**

B. **CLOO-AMON-ITT-EADLE**

C. **CRAI-URTIS-LLETTE-PLUMM**

D. **EJIOF-ONG'O-BERBAT-SSBEND**

E. **MCADA-UFFAL-EATO-UCCI**

F. **RANAGH-HOMPS-EEVE-SHINGT**

- -

MEMORABLE SCENES TRIVIA

Name the films from which these legendary edited sequences come from:

1. Janet Leigh in a shower.
2. A cut from Peter O'Toole blowing out a match to a sunrise in a desert.
3. Kevin Costner attempts to save a baby in a pram midway through a shootout with Chicago mobsters.
4. A group of boys chase a chicken down a street.
5. Faye Dunaway and Warren Beatty's outlaws are riddled with bullets.
6. A bone thrown by an ape transforms into a spaceship.
7. An eye is spliced open as clouds pass over the moon.
8. Carrie-Anne Moss freezes midair before dodging a hail of bullets.
9. A camera cuts away from a bedroom and mansion after a movie producer finds a horse's head in his bed.
10. A charging army massacres a crowd of civilians fleeing down the Odessa Steps.

THE SILENCE OF THE LAMBS

Parallel editing, or cross-cutting, allows a film to show a number of sequences unfolding in a different time or space simultaneously. Although film pioneer D.W. Griffith was not the first to use it in his films, he best understood the possibilities of it in films such as *The Birth of a Nation* (1915) and *Intolerance* (1916). In his 2010 cerebral action thriller *Inception*, Christopher Nolan used parallel editing to shift between four different timelines – the various levels of the protagonists' dream states.

But this style of editing not only helps collapse space and time, it can also play an essential role in creating tension within a sequence. This is what Jonathan Demme achieved in the lead-up to the climactic sequence of his Oscar-winning 1991 psychological thriller *The Silence of the Lambs*.

Working from a tip off, the FBI surround what they believe is the house of serial killer Jame 'Buffalo Bill' Gumb (Ted Levine). Meanwhile, agent Clarice Starling (Jodie Foster) completes her investigation by visiting the acquaintance of one of the victims. Demme and editor Craig McKay intercut the operation outside Gumb's house with footage of the killer inside his home. An agent rings the doorbell. But when the killer answers the door, its Clarice standing outside. The FBI unit storm the house, which is empty, with lead agent Jack Crawford (Scott Glenn) realizing the danger Clarice is in. Through the cross-cutting of the FBI operation, Clarice's investigation and events unfolding in Gumb's house, Demme successfully plays with our perception of space – leading us to believe the FBI and not Clarice is at Gumb's house, thus heightening the suspense for the film's climax.

Jodie Foster as Clarice Starling in *The Silence of the Lambs*

REDIRECT THE GAZE

Imagine you are plotting out a series of shots, to be later edited together one after another. Arrows in the grid below each represent a camera angle, and the numbers mark out the order in which the shots will be stitched together to give a varied focus on the events.

To plan out the shots, add numbers to the grid so that every square contains a number, and each number from 1 to 25 appears exactly once. Every number must be in a square that points in the precise direction of the next highest number (which may or may not be in the immediately neighbouring square) – and therefore the location of the next shot.

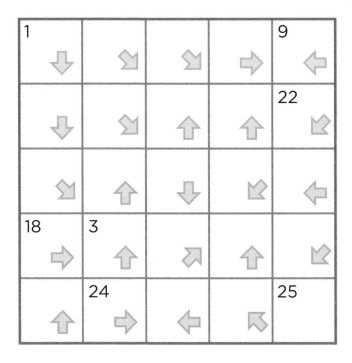

THE LONG SHOT

Editing is not always about cutting between shots. It is just as important to know how long to stay with one shot. Tension can just as easily be created in one uncut shot as it can in the combination of various shots.

Orson Welles showed this with the opening sequence of his 1958 film noir *Touch of Evil*. We see a bomb planted in a car and the car being driven across a town that straddles the US–Mexican border. Tension is relayed through the car's proximity to the main protagonists, played by Charlton Heston and Janet Leigh. It is all played out in one single shot. In Sam Mendes' *Spectre* (2015), a classic Bond opening action sequence, this time unfolding during Mexico's Day of the Dead celebrations, is carried out in one audacious single take. Some directors, such as Mexico's Alfonso Cuarón, Michelangelo Antonioni from Italy, Theo Angelopoulos from Greece, Béla Tarr from Hungary and Lav Diaz from the Philippines, are renowned for employing long takes in their films as a way of immersing audiences in the unfolding drama.

Other directors have pushed the single take to extremes, employing one shot for a whole film. *Victoria* (2015) is a crime thriller that unfolds over the course of 140 minutes at night in Berlin. *Boiling Point* (2021) is a ninety-four-minute drama taking place in a London restaurant. Most impressive of all is *Russian Ark* (2002), Aleksandr Sokurov's ninety-six-minute exploration through time in St Petersburg's Winter Palace that employs a cast of more than one thousand. Elsewhere, films have been edited to give the illusion of one take. Alfred Hitchcock pioneered this approach with his thriller *Rope* (1948), set in one room, but it can also be seen in *Birdman or (The Unexpected Virtue of Ignorance)* (2014) and *1917* (2019).

George MacKay in Sam Mendes' *1917*

BOILING POINT

Filmed in a real London restaurant, *Boiling Point* was shot in a single take using a carefully choreographed journey around the set. Imagine you are the film's director, plotting out a route for the film's action and the movement of the camera. Can you find a route through the labyrinth below, starting at the top and exiting at the bottom, so that you never have to go back on yourself – or worse, find yourself in a dead end?

A WORLD OF SOUND

From the moment audiences first experienced *The Jazz Singer* (1927), sound grew in importance to become as essential a part of the cinematic experience as visuals. It has become just as complex, involving an army of technicians and creatives to bring state-of-the-art audio into cinemas, from those recording and mixing it to the technology that surrounds us as a film unfolds.

Sound plays a vital role at every stage of the filmmaking process. Sound recordists may work in advance of a shoot, starting to capture elements key to a film. *Top Gun: Maverick* (2022) saw technicians ensconced with the US Navy to capture the actual sound of jet planes. These would be mixed in post-production with the recording of actors' voices and sounds

that are required during the film shoot. Actors may also be required to re-record their lines in post-production, in a setting where they sound clear. This process is known as ADR (Automated Dialogue Replacement).

Other sounds, from a gunshot or a punch to walking on leaves or jumping in water are created by foley artists. A sound editor will work with a sound mixer to find the right balance of all these elements. A sound designer may also be used to create a complex sound environment for a film. This might involve creating the right kind of silence in a scene to employing the subtlest form of white noise or a specific sound to affect the atmosphere, tone or rhythm of a scene.

A foley artist at work

NATURAL AND UNNATURAL

Each of the six animals concealed in 1 to 6 below has been incorporated into one of the sound effects listed beneath. Can you first reveal the name of each animal by deleting one letter from each letter pair, then match it to the correct sound effect?

1. SA WL LG IO NG LA ST EO RT

2. FC OR AU GA NA RG

3. CK RI OA SB

4. WE RL TE MP HL EA SN TY SM EP WA BL

5. SR YW OA NL

6. PW FA LO LR UF SN

A. **Mountain Banshees in *Avatar* (2009)**

B. **Ambient sound in Riley's mind in *Inside Out* (2015)**

C. **Wookiee language in *Star Wars* (1977)**

D. **Orc sounds in *The Lord of the Rings* series (2001–03)**

E. ***T. rex* in *Jurassic Park* (1993)**

F. **Decepticon named Frenzy in *Transformers* (2007)**

- -

SOUNDS EFFECTS TRIVIA

1. What form of household gadget was used to create the sound of light sabres in *Star Wars: Episode IV: A New Hope* (1977)?

2. Sounds created by trampling on packaged liver, jelly in a wet towel and a bag of popcorn were used to create which friendly alien's walk for a 1980s classic?

3. The hatching of what creature in a ground-breaking 1993 blockbuster was created by an ice-cream cone being crushed?

4. The sounds of drums, horses and elephants were combined for which Oscar-winning boxing film?

5. Which classic foley fruit prop was used to recreate the sound of a knife slicing into flesh for the famous shower scene in Alfred Hitchcock's *Psycho* (1960)?

THE GODFATHER

Francis Ford Coppola's *The Godfather* (1972) has long been hailed a masterpiece of cinema. The climactic sequence, where Michael Corleone (Al Pacino) has all his enemies executed is a brilliant example of parallel editing. Two earlier sequences in the film highlight the way that sound is employed to accentuate suspense.

Michael arrives at the hospital where his father, Don Vito Corleone (Marlon Brando) is being treated following a failed assassination attempt. Nino Rota's music highlights the drama of Michael discovering his father's bodyguards have been ejected from the hospital, leaving the Don vulnerable. But when Michael and a nurse move Vito to another room, the music stops and sound designer Walter Murch accentuates the silence with every small sound, emphasizing how alone they are. The quiet also adds power to Michael's acceptance that he is now part of 'the family' when he whispers to his father 'I'm with you now'. Music returns following the arrival of a family friend, as he and Michael await the appearance of potential assassins.

A few scenes later, Michael agrees to meet with the man who planned the assassination attempt, Sollozzo (Al Lettieri), and the corrupt police captain (Sterling Hayden) who protects him. Rota's music is drowned out by the sound of an overhead train as they arrive at the Italian restaurant where Michael plans to kill them. Murch added the train to rachet up the tension. Michael visits the toilet to retrieve a gun and when he returns to the table the sound of a passing train increases in volume, a cacophony that culminates in the shooting, followed by Michael quickly departing the restaurant and Rota's dramatic music returning.

Sterling Hayden's corrupt cop is shot by Al Pacino's Michael Corleone in *The Godfather*

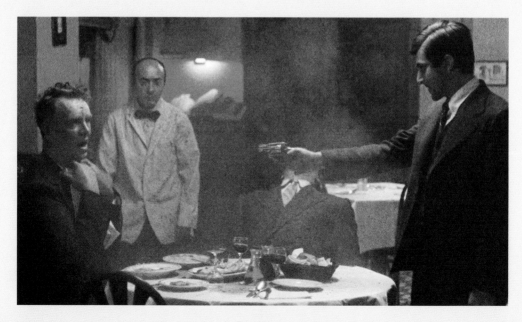

CUT AND OVERLAY

Imagine laying these two grids one on top of the other, to form a single word-search puzzle. Can you work out where you would find all but one of the capitalized actor's surnames below in the resulting picture, each of which may be written in any direction. Which one of the names cannot be found?

Al PACINO

Diane KEATON

Gianni RUSSO

James CAAN

John CAZALE

Marlon BRANDO

Morgana KING

Richard CONTE

Robert DUVALL

Sterling HAYDEN

Talia SHIRE

MUSIC

Music had long been an accompaniment to films in the pre-sound era. In most cases, a pianist or musician would improvise to the action or mood of each scene. In certain instances, a specific piece of music was intended for use. The arrival of *The Jazz Singer* (1927), the first narrative film with synchronous sound to play generally for audiences, combined a score with popular songs of the day. These two elements have become the staple for most soundtracks.

Between 1930 and 1950, the composed score developed into a sophisticated form, with composers such as Max Steiner and Erich Korngold employing the leitmotif, a melodic phrase, originally pioneered by Richard Wagner, which gave a theme to a character or recurring idea. In recent years this has been most successfully used by John Williams in his work with Steven Spielberg or on the *Harry Potter* films. Bernard Herrmann is another key composer from this era, who was just as capable of writing a swooning score as he was experimenting with radical or atonal music as he does with his music for *Citizen Kane* (1941), *Psycho* (1960) and *The Birds* (1963).

The influence of jazz most notably moved film scoring out of a classical European tradition of film composing, with early examples including Alex North's score for *A Streetcar Named Desire* (1952) and Miles Davis' improvised one-take response to Louis Malle's noirish *Lift to the Scaffold* (1958). In the same decade, the success of the song 'Do Not Forsake Me, Oh My Darling' in the film *High Noon* (1952) prompted studios to encourage composers to include a theme to promote a film. Over the years, this developed into the compilation soundtrack, which not only worked as a marketing tool but frequently became commercially successful in its own right.

Composer John Williams (left) and filmmaker George Lucas (right)

SOUND AND VISION

Can you match each of these composers to a track they
wrote, along with the movie it featured in? Then can you
match each of these to a still from the same movie?

Composers

1. John Williams
2. Hans Zimmer
3. Alan Silvestri
4. Bernard Herrman

Tracks

- ''85 Lone Pine Mall'
- 'Somewhere in My Memory'
- 'Temptation'
- 'Time'

Movies

Inception (2010)
Back to the Future (1985)
Psycho (1960)
Home Alone (1990)

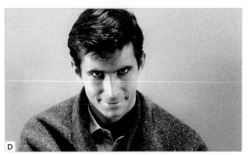

2001: A SPACE ODYSSEY

Stanley Kubrick's 1968 science-fiction opus was originally intended to feature a score by Alex North, who previously worked with the filmmaker on *Spartacus* (1960) and *Dr. Strangelove or: How I Learned to Stop Worrying and Love the Bomb* (1964). Instead, the film features a range of classical compositions by Richard Strauss, György Ligeti, Johann Strauss II and Aram Khachaturian.

While making his film, Kubrick employed a temporary – or temp – track, a series of previously composed pieces of music or songs that help a filmmaker work out the tempo or tone of a film as they are editing it. They might even use it on set during shooting to create a specific mood for the cast and crew. As work on his film developed, Kubrick became increasingly attached to these tracks, later responding to a critic's question about them, 'However good our best film composers may be, they are not

a Beethoven, a Mozart or a Brahms. Why use music which is less good when there is such a multitude of great orchestral music available from the past and from our own time? When you are editing a film, it's very helpful to be able to try out different pieces of music to see how they work with the scene . . . Well, with a little more care and thought, these temporary tracks can become the final score.'

North's score, which was eventually released as a recording, often bears an uncanny similarity to Kubrick's classical choices. His track 'The Foraging' was intended to be used in the same three points in the film that Kubrick used Richard Strauss' 'Also sprach Zarathustra'. However, there is little doubt that Kubrick's use of Johann Strauss II's 'Blue Danube' for the space docking and lunar sequences, and Ligeti's 'Atmosphères' for the Stargate scene is anything but inspired.

Keir Dullea in Stanley Kubrick's space epic

SPINNING WALTZ

Kubrick's use of Strauss's 'Blue Danube' was reportedly inspired by space itself: he claimed that the spinning of satellites while in orbit reminded him of dancers turning while performing a waltz. On a greater cosmic scale, the view below is full of spiral galaxies, each itself spinning around one of the given galactic centres. Can you mark out an area around each to ensure that it has enough room to spin, without encroaching on the space of any others?

Draw along some of the grid lines to divide the map into a set of regions, so that every square is in exactly one region. Each region must contain exactly one circle, and the region must be symmetrical in such a way that if rotated 180 degrees around the circle it would look exactly the same.

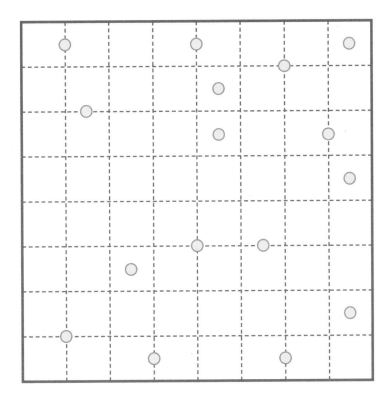

ENNIO MORRICONE

Few figures in the world of film composition became as iconic in their lifetime, or were as prolific, as Ennio Morricone. The son of a musician who learned to play trumpet at an early age, he began composing music when he was six. At the age of twelve, he completed a four-year harmony course at a conservatory in just six months and looked set to be a classical composer.

As well as becoming a member of the avant-garde collective The Group (Gruppo di Improvvisazione Nuova Consonanza) in 1964, by his early twenties Morricone was composing and arranging for radio, television and pop artists. He brought an originality and eclectic use of instrumentation to popular song, which he would continue to do for the rest of his career. It was this innovation, a willingness to experiment with sound, that saw him drawn to film. He worked uncredited on a variety of films in the late 1950s before receiving his first official credit as composer on Luciano Salce's *The Fascist* (1960).

Morricone's key relationship in this era was with filmmaker Sergio Leone. His scores for Leone's spaghetti westerns *A Fistful of Dollars* (1964), *For a Few Dollars More* (1965), *The Good, the Bad and the Ugly* (1966) and *Once Upon a Time in the West* (1968) helped redefine the genre and were radically different to any score that had come before. Morricone also innovated with his score for director (and co-composer) Gillo Pontecorvo's *The Battle of Algiers* (1966).

Morricone would work prolifically in film for the next fifty years, composing such iconic scores as those for Leone's *Once Upon a Time in America* (1984), *The Mission* (1986), *The Untouchables* (1987), *Cinema Paradiso* (1988) and *The Hateful Eight* (2015), for which he finally won his first and only Academy Award for Best Original Score.

BACK TO THE BEGINNING

In *Cinema Paradiso*, the film's protagonist returns to his Sicilian hometown and the scene of his formative experiences as a young filmmaker. Can you use your skills of logic and deduction to reveal the name of the town in the grid below?

Place one of the letters A, C, D, E, G, I, L, N or O into each empty square, so that no letter repeats more than once within any row, column or bold-lined 3×3 box. Once complete, the name of the town will be revealed in the shaded diagonal, reading from top to bottom.

			A	N	I			
		O		G		E		
	L			E			G	
E								I
A	N	L				D	O	G
D								L
	E			A			C	
		N		I		A		
			E	D	N			

VISUAL EFFECTS

Visual effects, generally seen as the integration of live-action footage with generated imagery – as opposed to physical, in-camera special effects – date all the way back to 1857 and early image effects created by Oscar Rejlander. He combined various parts of thirty-two negatives into one single composite image. A similar tactic was employed by Georges Méliès with many of the films he made between 1896 and 1913.

Various kinds of effects would be employed over subsequent decades, with the credit 'special effect' first being used on the comedy-drama *What Price Glory?* (1926). But it was in the 1950s, with the increasing popularity of science fiction, that visual effects became more common. From *War of the Worlds* (1953) to *Forbidden Planet* (1956), an increasing sophistication was employed in creating dazzling screen effects.

The development of computer graphics in the 1970s ushered in a new dawn in visual effects. The trend for disaster movies, alongside blockbusters such as *Star Wars* and *Close Encounters of the Third Kind* (both 1977), saw a rapid escalation in the development of innovative new technologies. The speed of this would only increase in the 1980s and 1990s with the emergence of computer-generated imagery, which first appeared in *Star Trek II: The Wrath of Khan* (1982) and was developed further in *Terminator 2: Judgment Day* (1991) and *Jurassic Park* (1993). *The Matrix* (1999) introduced bullet-time effects that appeared to freeze characters in space as others moved around them, while *The Lord of the Rings* trilogy (2001–03) made astonishing use of performance capture technology, particularly with the creation of Gollum. The combination of IMAX technology, advances in digital technologies and the occasional enthusiasm for 3D have helped push visual effects in the twenty-first century to the point where anything can be created.

Andy Serkis plays Gollum in Peter Jackson's adaptation of Tolkien's Middle Earth novels

ANIMAL ANTICS

Each of these pictured films prominently features a computer-generated animal – or in some cases, several. The corresponding film titles are also given below, but the text seems to have glitched and the names have broken into various fragments. Can you piece these fragments back together to restore the names of the four films?

ASS	ASSI	CWO	DENC
EGOL	ENA	EOF	JUR
LIF	NT	OMP	PI
REV	RLD	TH	THE

JAMES CAMERON

With his sci-fi adventure short film *Xenogenesis* (1978), James Cameron signalled the direction his career would lead him. After taking over the direction of *Piranha II: The Spawning* (1982), Cameron enjoyed enormous success with the sci-fic action-thriller *The Terminator* (1984). A low-budget chase movie that employed impressive special and visual effects, it became a hit that distilled the filmmaker's willingness to experiment with technologies against a passion for traditional storytelling form.

With *Aliens* (1986), Cameron took Ridley Scott's original sci-fi horror and transformed it into a war film on a distant planet. Physical effects dominated, the increased scale of the production underpinning Cameron's increasing ambitions. These were further realized with *The Abyss* (1989), a story about an undersea disaster that transforms into a race against time and an encounter with an alien species. The film is notable for the use of rapidly developing computer-generated technology. In retrospect, that film resembles a dry run

for his next film, *Terminator 2: Judgment Day* (1991), a sequel to his 1984 success, played out on an epic scale. Very much a line in the sand as far as visual effects is concerned, the film now stands as a landmark in the form's development, with sequences that still astound.

After the knockabout antics of the intentionally overblown spy adventure *True Lies* (1994), Cameron recreated the maritime world's most famous shipping disaster with *Titanic* (1997). Once again, Cameron revelled in the use of complex visual effects to recreate the voyage and tragic events that ended it. But the scale of this film – along with its record as the biggest-grossing film of all time – were overtaken by *Avatar* (2009). Cameron spent a decade waiting for visual effects to allow him to realize the world of Pandora, the moon across which his film unfolds. And it is a world that will likely dominate the rest of his career, with *Avatar: The Way of Water* (2022) to be followed by multiple adventures in this entirely imagined domain.

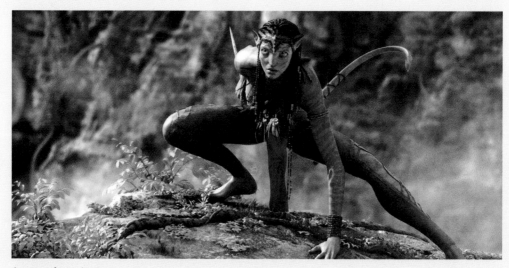

A scene from *Avatar*

A DEEP DIVE

Alongside his filmmaking, James Cameron has undertaken a series of daring deep-sea dives, including reaching the deepest point in the world's ocean. Aside from producing several documentaries filmed in the deep ocean, his dives also play an important part in his filmmaking process.

Can you match each of the watery scenes below to the name of the Cameron film from which it is taken?

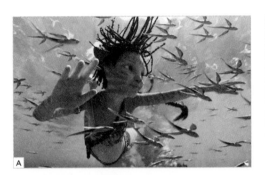

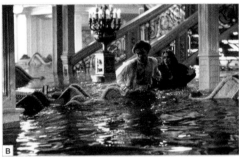

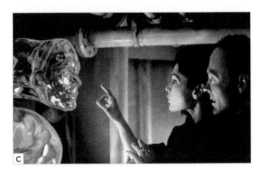

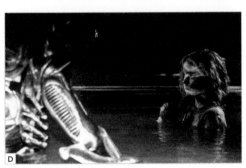

CAMERON TRIVIA

Match each character to the correct film.

The Characters
1. Sarah Connor
2. Neytiri
3. Dr. Lindsey Brigman
4. Ripley
5. Helen Tasker

The Films
A. *The Abyss*
B. *The Terminator*
C. *Aliens*
D. *Avatar*
E. *True Lies*

6

Selling the Movie

While a film is in production, another part of the industry is hard at work preparing for its release. After all, it is not just the professional reputation of the director, cast and crew that is at stake. Even the most modestly budgeted film costs a small fortune, and a studio or production company will want to make good on that spend. Of course, the publicity machine involved in promoting a film will depend on the scale and budget of the production in question.

A low budget, limited release may have to rely on minimal advertising, an eye-catching trailer, good reviews and great audience word of mouth. If the first few days are strong, then it may be 'held over' by cinemas – enjoying a longer stay and greater box office. Before the advent of blockbuster releases like *The Godfather* (1972) and *Jaws*

(1975), most films were rolled out gradually. Times have changed and films of all sizes tend to have as wide a release as possible on their opening weekend. Moreover, all eyes are on the box office figures to see how audiences react to a film. A bad opening weekend can be a film's death knell.

Larger productions enjoy greater promotion. A major blockbuster will have a promotional spend that is greater than the production budget of an independent film. And all major names involved will be required to go on a publicity tour to promote it. For studios, this has become a well-oiled operation that is essential in ensuring the highest levels of FOMO for a new film. And it all starts with the copywriters who come up with a hook for the film and the artists who create an indelible image to sell it.

THE ARTWORK

In the spring of 1989, an ad campaign for an upcoming blockbuster was launched, showing up on billboards and the sides of public transport. There was no title, just a symbol and a date. But everyone knew what the film was. *Batman*'s production designer Anton Furst came up with the design that encapsulated Tim Burton's darker vision of DC's morally ambivalent crime crusader. And his work highlighted the importance of the film poster in the promotion of a film.

Film posters are as old as cinema. Marcellin Auzolle's illustration for Auguste and Louis Lumière's 1895 short *L'Arroseur Arrosé* is believed to be the first promotional film poster. But it was as cinema transformed from being a sideshow attraction to a major business that the potential of film posters as a form of advertising was fully realized. And as publicity machines became more sophisticated, so posters embraced the psychology of the sales pitch, finding ways to lure audiences into cinemas to see the latest release. The challenge lay in enticing audiences with a combination of tone and content: give a sense of what the film is about and how it will make a viewer feel, but without being so specific to exclude a wide audience – or giving too much away!

Some posters proved ruthlessly effective, such as *Jaws* (1975), with an oversized shark, teeth bared, just feet beneath a female swimmer, and the film's title in blood red. The first *Star Wars* series (1977–83) relied on the combinations of multiple smaller images of characters and moments from the films, while Juan Gatti's work on the films of Pedro Almodóvar, employ the filmmakers' trademark use of bold colours, combined with kitsch elements and the whiff of the illicit that often permeates the films. But such designs are only a success if people buy tickets to see the films.

Roger Kastel's promotional poster for *Jaws*

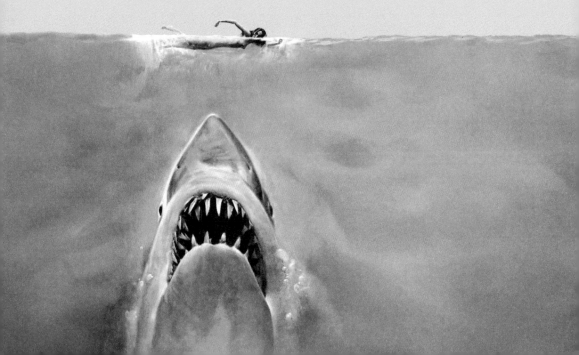

STARK CONTRASTS

Each of these stark images is taken from a movie poster – but for which film? The names of the four movies are given beneath, but the titles have had their letters jumbled and are listed in a different order. Unscramble them and then match each one to its corresponding iconic poster image.

A. ABSORB MY YEARS (9, 4)

B. NICE HOT FLESH = BEST MEAL (3, 7, 2, 3, 5)

C. EGO TUT (3, 3)

D. DAUGHTER TEA (3, 8)

ALIEN

The finest posters are often the perfect partnership between image and tagline. The tagline, like its accompanying artwork, is aimed at enticing audiences to see the film. There have been some priceless examples, from 'Who you gonna call?' for *Ghostbusters* (1984), 'The first casualty of war is innocence' for *Platoon* (1986) and 'Houston, we have a problem' for *Apollo 13* (1995) to 'In a galaxy far, far away . . .' for *Star Wars* (1977). But few film posters and taglines have combined as effectively as the promotional artwork for *Alien* (1979).

Ridley Scott's film was a genre hybrid – a horror sci-fi. Moreover, the horror was in the subgenre of the slasher film, which had officially existed for less than a decade. The poster design was the brainchild of Philip Gips, who had already scored several successes with his artwork for *Rosemary's Baby* (1968) and *Downhill Racer* (1969), both featuring dream-like images. He also led the advertising campaign for the release of *Superman: The Movie* in 1978. But his idea for *Alien* was different, underpinning the qualities that made the film unique. The egg that hatches the deadly extraterrestrial can be seen hovering above an abstract landscape, partially illuminated by the otherworldly light that seeps out, like a gas, from a crack in the lower half of the egg. In the darkness above it, the film's title appears coldly, the Helvetica Black font is the same used in the film's opening credits. And to add to the sense of unease the poster emanates, there's the tagline: 'In space no one can hear you scream'. It was conjured up by the copywriter Barbara Gips, a throwaway line that her husband incorporated into his artwork and which the studio producing the film were more than happy to use.

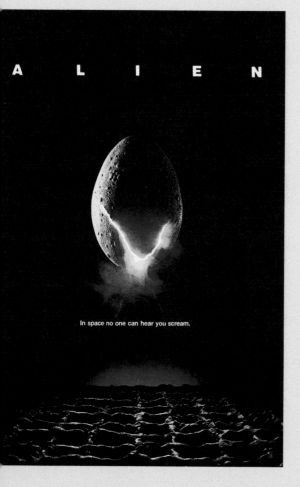

Philip and Barbara Gips' promotional poster for Ridley Scott's successful genre-hybrid

TAGLINES

Each of the movie taglines below has had its words rearranged into alphabetical order. Can you restore the original ordering, then match each slogan to the correct movie listed beneath? Punctuation has been ignored, although uppercase letters have been preserved.

1. 'and in kill love people they They're they're young'

2. 'a fake of real story The true'

3. 'air On the Unaware'

4. 'alone are not We'

5. 'be but dead He he's life may of party the the'

6. 'easy it man's One struggle take to'

7. 'a is man mission The'

8. 'be Everyone found to wants'

A. *Bonnie and Clyde* (1967)

B. *Catch Me If You Can* (2002)

C. *Close Encounters of the Third Kind* (1977)

D. *Ferris Bueller's Day Off* (1986)

E. *Lost in Translation* (2003)

F. *Saving Private Ryan* (1998)

G. *The Truman Show* (1998)

H. *Weekend at Bernie's* (1989)

THE CRITICS

There is a scene in Samuel Beckett's *Waiting for Godot* (1952), when Vladimir and Estragon are hurling insults back and forth at each other. It climaxes with Estragon shouting 'Critic!' at his acquaintance. That 'insult' summed up what Beckett thought about the profession that reviews the arts. But the critic is an essential part of the cultural world. And in cinema, the 'seventh art', as Italian film theorist and critic Ricciotto Canudo described it, criticism and reviewing has become an industry unto itself.

As film developed into an art form in the late 1910s and 1920s, with the emergence of German expressionism, Soviet constructivist filmmaking and other experimental cinematic forms, writings about it increased. In 1933, the weekly entertainment newspaper *Variety* began publishing *Daily Variety* from Los Angeles, covering the rapidly expanding film industry. It would remain the industry bible, joined, in time, by the *Hollywood Reporter*, *Screen International* and, with the inception of the internet *IndieWire*. Critical thinking became more nuanced with each passing decade. In the United States, there was James Agee, Manny Farber, Andrew Sarris and Pauline Kael. In the United Kingdom, the film journal *Sight and Sound* was created in 1932 and has become one of the most widely read film journals. Other publications began to appear in countries around the world, none more influential than the French *Cahiers du Cinéma*. Founded in 1951, it attracted a new generation of writers, such as François Truffaut, Jean-Luc Godard, Claude Chabrol, Jacques Rivette and Eric Rohmer, who would go on to form the French New Wave movement of filmmakers. The influence of critics may have dwindled with time – some big films are frequently referred to as 'critic-proof' – but they remain an essential part of film culture, identifying new trends and styles in cinema, and most importantly, championing up-and-coming talent.

Jimmy Woodard (left) and Robert Townsend (right) in *Hollywood Shuffle* (1987)

EVERYONE'S A CRITIC

Can you use your mathematical skills to reveal more
information about four films that were originally panned by
some of the critics? Starting with the number on the left,
perform each of the mathematical operations in turn from left
to right. In the final, empty box, write in the resulting number
to reveal the solution to the clue given above each puzzle.

1. *Fight Club* (1999): **Percentage of the audience
 that was male, leading to it being dubbed
 'the ultimate anti-date flick'**

12	+ 32	÷ 4	x 6	- 5	

2. *It's a Wonderful Life* (1946): **Box office loss
 for the film in US dollars**

7	x 7	+ 56	x 5	x 1000	

3. *The Shining* (1980): **Total number of Oscar,
 Golden Globe and BAFTA awards won**

18	x 5	+ 10	÷ 4	- 25	

4. *The Wizard of Oz* (1939): **Number of years
 passed before the film was considered to
 have turned a profit**

12	÷ 8	x 10	÷ 3	x 2	

THE FESTIVAL CIRCUIT

The film festival has become an essential part of world cinema. Where it once championed new films, often through competition, and revelled in the glamour of the industry, today it is as much a part of the business of film as it is the exhibition of it. There are hundreds of festivals around the world, but to those not involved in the promotion or screening of them, only a handful capture the headlines.

There are five annual film festivals generally regarded as the most important. The Venice International Film Festival is the oldest and one of the most regal, with its main prize the Golden Lion. Founded in 1932 by Mussolini's fascist government, it wasn't until after the Second World War that it came into its own. It unfolds at the end of summer and, thanks to its setting, attracts a wealth of international stars. The Berlin International Film Festival was founded in 1951 and takes place every February, in the heart of the German winter. Its main prize is the Golden Bear and the event covers every aspect of film, from mainstream blockbusters to experimental works. The two North American entries are more recent. The Sundance Film Festival, set in the snow-capped mountains of Colorado, was created with Robert Redford in the mid-1980s. Initially championing independent American film, it has now broadened its scope to encompass independent cinema. And Toronto International Film Festival, which was founded in 1976 and crosses over with Venice in the calendar, is very much an audience festival. The last two decades have seen Toronto's importance increase as the starting point for the awards season, which culminates in the Academy Awards the following spring. But above these festivals is the festival to rule them all: Cannes Film Festival.

The festival red carpet

COMPLETING THE CIRCUIT

Plan a loop around the festival circuit by visiting each of the 'Big Five' film festivals in the order in which the film festivals are held during the year. Each letter in the grid is the initial letter of the name of the festival in question. To reveal this order, find the one way to draw a loop that visits every white square, without visiting any square more than once, and which is made up of only horizontal and vertical lines. It cannot enter any of the shaded squares. Once complete, read the initials clockwise around the loop from the top-left square, to reveal the order in which the film festivals are held throughout the year.

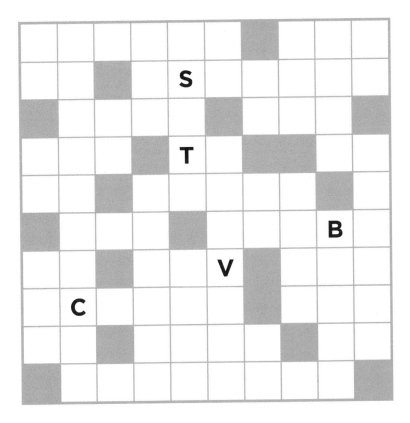

CANNES FILM FESTIVAL

Created in 1946, and unfolding every May in the city on the French Riviera, the Cannes Film Festival is arguably the most important fixture in the world cinema calendar. To look at the films that have screened in and out of competition is to witness the history of cinema over the course of the last eight decades; not just the key films that have been made, but the trends, waves and movements, controversies and surprises.

The festival's main prize is the Palme d'Or, or Golden Palm. It is awarded to the film chosen by the jury for the main competition. There are a number of other, no less worthy competitions that play out during the festival's run (which usually lasts twelve days), from Un Certain Regard and Directors' Fortnight to Caméra d'Or, which rewards the best debut film in a festival. There are dozens of awards, even one, the Palm Dog, that gives a prize to

the best canine performance in a film. To win the main prize at the festival is to guarantee a film's passage to general release around the world. It is a stamp of approval that is recognized by general audiences and as such can be used to market a film.

The list of Palme d'Or-winning films is impressive, from *The Third Man* (1949), *The Leopard* (1963) and *M*A*S*H* (1970) to *Paris, Texas* (1984), *The Piano* (1993), *4 Months, 3 Weeks and 2 Days* (2007) and *Titane* (2021). That last film was one of the more controversial winners over the years, a category that also includes David Lynch's *Wild at Heart* (1990) and Lars von Trier's *Dancer in the Dark* (2000). In fact, as any regular attendee knows, Cannes would not be Cannes without some members of the audience booing a film.

WINNING SCENES

Each of the four pictured films won the Palme
D'Or in its year of entry. Can you identify each
of the movies? Their anagrammed titles are
listed below, as a hint.

1. **SET CLASH** (3, 5)

2. **HEAP INTO** (3, 5)

3. **CRUMBLIEST OUTLAW HEROES** (4, 2, 3, 7, 6)

4. **IDEAL IN BLEAK** (1, 6, 5)

THE AWARDS SEASON

Whereas film award ceremonies were once independent events, it is now a cavalcade of national and regional awards ceremonies that culminate every spring when all roads lead to the Oscars.

Each country or region has its own awards. There are the Césars in France, the Genies in Canada, the Goyas in Spain, the Magrittes in Belgium, the Blue Dragons in Korea, the Macondos in Colombia and David di Donatellos in Italy, as well as many awards named after the country they are given in. The European Film Awards and the Golden Horse Awards for Chinese language film cover their respective areas. It is not always a given that the winners of the top awards in these countries immediately become a country's choice for submission to the Academy Awards, but it can feel like each of these awards ceremonies is a build-up to what has become the world's most publicized event.

Each award ceremony covers all areas of filmmaking, from every aspect of craft to the work of writers, directors and actors. And most awards ceremonies end with acknowledgement of the best film for that country or region, which is generally accepted by one or more of the film's producers. From a commercial perspective, these awards can help bolster the box office rewards for a film. This is particularly true of lower-budget films that profit from the increased exposure of an awards win. None more so than *Parasite* (2019), one of the few films to win at both Cannes and the Academy Awards.

Cate Blanchett

EYES ON THE PRIZE

On each line below, the name of a prestigious movie award
has been blended with the name of the country that awards it.
Can you separate the two to reveal the list of coveted prizes?
Note that each prize is identified by its familiar name, rather
than any more lengthy, official title it may have.

1. MAERXIIECOL

2. BLKUEODRERAGAON

3. FCRÉANSCAER

4. EPOALGALNDE

5. SGOOUTLHDAEFNRHIORCNA

6. GOCLDHENIROONSTAER

7. SPGAOYIAN

8. GLEORMALANY

9. MCOALCOMOBNIDAO

10. BMEALGGRIIUTTME

11. OUSSCARA

12. RDEONMBAERTRK

13. SPOROPTHUGIAAL

- -

TROPHY TRIVIA

1. Only two films have ever won the top
prize at Cannes and the Oscars.
Which of the following are they:
- *Marty* (1955)
- *The Leopard* (1963)
- *M*A*S*H* (1970)
- *Taxi Driver* (1976)
- *Apocalypse Now* (1979)
- *Amour* (2012)
- *Parasite* (2019)

2. What Oscar achievement is shared by just
three films: *It Happened One Night* (1934),
One Flew Over the Cuckoo's Nest (1975)
and *The Silence of the Lambs* (1991)?

ACADEMY AWARDS

The Academy Awards, more commonly known as the Oscars, marked the first film awards ceremony. It took place on 16 May, 1929, in front of an audience of 270 invited guests at The Hollywood Roosevelt Hotel in Los Angeles. Twelve awards were handed out and the whole presentation lasted just fifteen minutes. It is a contrast to the glitzy, media-saturated, star-laden behemoth that the awards ceremony has become.

Lasting much longer than almost all the films that have been nominated in one of its categories, the Academy Awards ends a season, beginning with the Telluride and Toronto International film festivals in North America and, to a lesser degree the Venice International Film Festival, when potential nominees begin a two-stage race; first to secure a nomination and then the final stretch towards being the winning film on Oscar night.

There are a few legends around how the 'Oscar' got its name. The most popular is that Margaret Herrick, a librarian at the Academy of Motion Picture Arts and Sciences, apparently named it after her uncle. It was first used by Hollywood columnist Sidney Skolsky in a piece he wrote about Katharine Hepburn's first Best Actress win, for *Morning Glory* (1933), in 1934. But it has come to be regarded as the highest achievement in commercial cinema.

What was once a slim, brief ceremony, has transformed into a showbiz cavalcade. On many an occasion the best film of the year has not won – and in some cases was not even nominated. But that is all part of an event that revels in both the show and business of the film world.

Directors Daniel Kwan and Daniel Scheinert along with the cast and crew of *Everything Everywhere All at Once*, accepting the Best Picture Oscar at the 2023 Academy Awards

LINE THEM UP

Each of the artists in the table below has won an Oscar for their work in one of the listed categories on one of the listed films. Some of the artists and films have won multiple Oscars, but can you fill in the empty boxes in the table so that each category and film is used exactly once each, and so that each artist is correctly associated with an Oscar they have won?

When completing the grid, also copy in the extra letters given in brackets next to each category and film – and then, once the table is complete, read these added letters in each column from top to bottom to reveal the name of the first person born in the twenty-first century to win an Oscar.

Artists	Category	Film
Chloé Zhao		
Ben Kingsley		
Emerald Fennell		
Frances McDormand		
Jenny Beavan		
Taika Waititi		

Categories

Best Actor (I)
Best Actress (L)
Best Adapted Screenplay (E)
Best Costume Design (I)
Best Director (B)
Best Original Screenplay (L)

Films

Cruella (2021) (S)
Fargo (1996) (I)
Gandhi (1982) (I)
Jojo Rabbit (2019) (H)
Nomadland (2020) (E)
Promising Young Woman (2020) (L)

- -

OSCAR TRIVIA

1. What is the only non-American, foreign language film to have won a Best Picture Academy Award?

2. Which director, a master of suspense, never won a competitive Oscar across his five-decade career?

3. Which actor declined the Best Actor Oscar in 1973?

4. At the 2016 Academy Awards, the wrong film was announced as Best Picture winner. What was the title of that film and of the film that did win?

5. What role, essential to most blockbuster films, was rejected as a proposed awards category between 1991 and 2012?

The Answers

Page 11: The Script
The Power of Language
1. *Parasite* – KOREAN (F)
2. *The Seventh Seal* – SWEDISH (H)
3. *Seven Samurai* – JAPANESE (E)
4. *Pan's Labyrinth* – SPANISH (G)
5. *The Hunt* – DANISH (B)
6. *The Lives of Others* – GERMAN (C)
7. *City of God* – PORTUGUESE (A)
8. *Life is Beautiful* – ITALIAN (D)

Screenplay Trivia
1. *Chinatown*
2. *American Beauty*
3. Orson Welles, for *Citizen Kane*
4. Seven: 1917, 1918, 1933, 1949, 1994, 2018 and 2019
5. *Miller's Crossing*

Page 13: Crime
Double Lives
1. *CHINATOWN* – Jake Gittes (Jack Nicholson)
2. *VERTIGO* – John 'Scottie' Ferguson (James Stewart)
3. *GOODFELLAS* – James Conway (Robert De Niro)
4. *SCARFACE* – Tony Montana (Al Pacino)
5. *SEVEN* – David Mills (Brad Pitt)
6. *JOKER* – Arthur Fleck (Joaquin Phoenix)
7. *COLLATERAL* – Vincent (Tom Cruise)
8. *FARGO* – Marge Gunderson (Frances McDormand)

Thriller Trivia
1. *Looper*
2. The films are all adaptations of novels by legendary crime writer Raymond Chandler
3. Quentin Tarantino's *Pulp Fiction*
4. Christopher Nolan's *Memento*
5. Steven Spielberg's *Minority Report*

Page 15: The Western
Western Letterfit
The letters can be arranged to spell SERGIO LEONE, director of the Dollars trilogy starring Clint Eastwood.

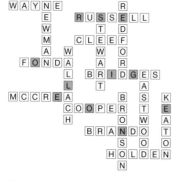

Page 17: The Screwball Comedy
One-Liners
1. 'I see a man in your life.' – F: 'What, only one?'
2. 'I changed my mind.' – B: 'Does it work any better?'
3. 'I've heard so much about you.' – D: 'Yeah, but you can't prove it.'
4. 'Aren't you forgetting that you're married?' – C: I'm doing my best.'
5. 'I'll never forget you.' – E: 'No-one ever does.'
6. 'What do you want to do, drive me to the madhouse?' – A: 'No, I'll call you a taxi.'

Page 19: Melodrama
The Close-Up
1. *Gone with the Wind* – VIVIEN LEIGH
2. *Casablanca* – INGRID BERGMAN
3. *Volver* – PENELOPE CRUZ

Page 21: Horror
Where on Earth?
1. *A Nightmare on Elm Street* – USA (F)
2. *Midsommar* – Sweden (D)
3. *Ring* – Japan (B)
4. *Suspiria* – Germany (A)
5. *The Skin I Live In* – Spain (C)
6. *28 Days Later* – UK (E)

Page 23: Sci-Fi and Fantasy
Picture Perfect
1. *A Trip to the Moon*
2. *First Men in the Moon*
3. *E.T. the Extra-Terrestrial*
4. *2001: A Space Odyssey*

Page 25: Superheroes
Secret Identities
Batman: BRUCE
Black Widow: NATASHA
Captain America: STEVEN
Catwoman: SELINA
Iron Man: TONY
Shazam: BILLY
Spider-Man: PETER
Superman: CLARK
The Flame: GARY
Wonder Woman: DIANA

Page 27: The Musical
Musical Maestro
1. 'Cheek to Cheek' – *Top Hat* (A)
2. 'Chim Chim Cher-ee' – *Mary Poppins* (L)
3. 'City of Stars' – *La La Land* (A)
4. 'Hopelessly Devoted to You' – *Grease* (N)
5. 'Let It Go' – *Frozen*
6. 'Let's Hear it for the Boy' – *Footloose* (M)
7. 'Over the Rainbow' – *The Wizard of Oz* (E)
8. 'Remember Me' – *Coco* (N)

9. 'Shallow' – *A Star is Born* (K)
10. 'The Trolley Song' – *Meet Me in St Louis* (E)
11. 'When You Wish Upon a Star' – *Pinocchio* (N)

The letters spell ALAN MENKEN – winner of four Oscars for Best Original Song, and nominated for fourteen.

Musicals Trivia
1. a. *West Side Story* (1957)
 b. *My Fair Lady* (1964)
 c. *High Society* (1956)
2. a. *The Broadway Melody*
 b. *An American in Paris*
 d. *The Sound of Music*

Page 29: Film Noir
Shady Characters

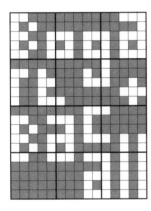

The revealed image reads 'Bogart + Bacall', referring to Humphrey Bogart and Lauren Bacall. As well as appearing individually in other film noir movies, the couple (who were married in real life) famously starred together in *The Big Sleep* (1946).

Page 31: The Romantic Comedy
The Perfect Match
1. Halle BERRY and Eddie MURPHY – *Boomerang*
2. Katharine HEPBURN and Cary GRANT – *The Philadelphia Story*
3. Audrey HEPBURN and Gregory PECK – *Roman Holiday*
4. Meg RYAN and Tom HANKS – *Sleepless in Seattle*
5. Kate HUDSON and Matthew MCCONAUGHEY – *How to Lose a Guy in 10 Days*
6. Eva MENDES and Will SMITH – *Hitch*
7. Helen HUNT and Jack NICHOLSON – *As Good As It Gets*
8. Julia ROBERTS and Richard GERE – *Pretty Woman*

Romance Trivia
1. *The Apartment* (1960)

2. *Groundhog Day* (1993)
3. *Sleepless in Seattle* (1993)
4. *An Affair to Remember* (1957)
5. *Ticket to Paradise* (2022)

Page 33: Iconic Lines
Missing Icons
1. 'Here's **looking** at you, kid!' – *Casablanca* (B)
2. 'You had me at "**hello**"' – *Jerry Maguire* (E)
3. 'I'm gonna make him an **offer** he can't refuse.' – *The Godfather* (H)
4. 'You **talking** to me?' – *Taxi Driver* (G)
5. 'I ate his liver with some **fava** beans and a nice Chianti.' – *The Silence of the Lambs* (J)
6. 'You're gonna need a bigger **boat**.' – *Jaws* (D)
7. 'Nobody puts **Baby** in a corner.' – *Dirty Dancing* (C)
8. 'I have always depended on the **kindness** of strangers.' – *A Streetcar Named Desire* (A)
9. 'Mrs Robinson, you're trying to **seduce** me. Aren't you?' – *The Graduate* (I)
10. 'A boy's best friend is his **mother**.' – *Psycho* (F)

CHAPTER 2: PLAYING THE PART

Page 37: The Early Years
Stars and Studios

Page 39: Buster Keaton
Training Day

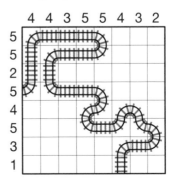

Page 41: The Golden Age of Hollywood
Golden Tickets
1. *CASABLANCA*
2. *CITY LIGHTS*
3. *IT HAPPENED ONE NIGHT*
4. *GONE WITH THE WIND*
5. *HIS GIRL FRIDAY*
6. *SINGIN' IN THE RAIN*
7. *SOME LIKE IT HOT*
8. *TO CATCH A THIEF*
9. *IT'S A WONDERFUL LIFE*
10. *CITIZEN KANE*
11. *BREAKFAST AT TIFFANY'S*
12. *ALL ABOUT EVE*

Golden Age Trivia
1. *Gone with the Wind*
2. Bette Davis and Joan Crawford
3. Clark Gable

Page 43: Cary Grant and Katharine Hepburn
Piece by Piece
The missing piece should read 'IDBE'. The names are:
- HUMPHREY BOGART
- INGR**ID BE**RGMAN
- JAMES STEWART
- JOAN FONTAINE
- MAE WEST
- SPENCER TRACY

Page 45: Child Actors
First Class
1. Natalie Portman – 12; *Léon: The Professional*
2. Drew Barrymore – 7; *E.T. the Extra-Terrestrial*
3. Kirsten Dunst: – 8; *The Bonfire of the Vanities*
4. Scarlett Johansson – 13; *The Horse Whisperer*
5. Ethan Hawke – 15; *Explorers*
6. Nicholas Hoult – 11; *About a Boy*
7. Abigail Breslin – 9; *Little Miss Sunshine*
8. Mara Wilson – 5; *Mrs Doubtfire*

Page 47: It's all in the Method
Blurring the Lines
1. DANIEL DAY-LEWIS + BILL THE BUTCHER – *Gangs of New York* (B)
2. DIANE KEATON + LINDA CHRISTIE – *Play It Again, Sam* (D)
3. DUSTIN HOFFMAN + BENJAMIN BRADDOCK – *The Graduate* (H)
4. GREGORY PECK + JOE BRADLEY – *Roman Holiday* (F)
5. JANE FONDA + EILEEN TYLER – *Sunday in New York* (G)
6. MARLON BRANDO + STANLEY KOWALSKI – *A Streetcar Named Desire* (A)
7. MARILYN MONROE + LORELEI LEE – *Gentlemen Prefer Blondes* (C)
8. ROBERT DE NIRO + JAKE LAMOTTA – *Raging Bull* (E)

Page 49: Stars in Europe
Leading Ladies
The letters can be rearranged to spell the surname of Marion COTILLARD.

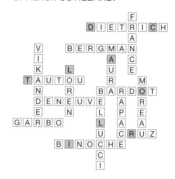

Page 51: Jeanne Moreau
The Love Triangle

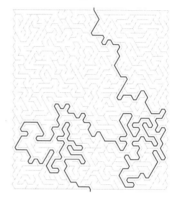

Page 53: Bollywood
Leading Legend
The name spelled out is MALA SINHA.

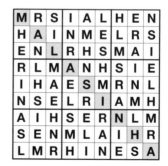

Page 55: Asian Stars
Jackie Chan
1. *Drunken Master*
2. *The Fearless Hyena*
3. *The Young Master*
4. *Winners and Sinners*

5. *Twinkle, Twinkle, Lucky Stars*
6. *Island of Fire*
7. *Crime Story*
8. *The Accidental Spy*

Page 57: Tony Leung
International Stories
1. BUENOS AIRES – *Happy Together*
2. TAIPEI – *A City of Sadness*
3. HONG KONG – *Hard Boiled*
4. SHANGHAI – *Lust, Caution*
5. HO CHI MINH CITY – *Cyclo*
6. MANILA – *Days of Being Wild* (1990)

Tony Leung Trivia
1. *The Departed*
2. A spy
3. *Fallen Angels*

Page 59: Hollywood Action Stars
Running the Numbers
1. 2029: The year the Terminator is sent back from in *The Terminator*
2. Jupiter 16: Name of the NASA spaceship hijacked in *You Only Live Twice*
3. 7: Number of crew members on the Nostromo at the start of *Alien*
4. 4: The number of dollars in millions set as a final bounty in *John Wick*

Page 61: Tom Cruise
Still Life: Tom Cruise Movies
A. Brian in *Cocktail*
B. Pete in *Top Gun*
C. Daniel in *A Few Good Men*
D. Charlie in *Rain Man*
E. Jerry in *Jerry Maguire*
F. Ethan in *Mission: Impossible*

Page 63: Julia Roberts
The Other Halves
1. *Closer* – Jude LAW
2. *Eat Pray Love* – Javier BARDEM
3. *Hook* – Robin WILLIAMS
4. *Notting Hill* – Hugh GRANT

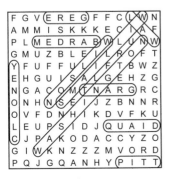

5. *Pretty Woman* – Richard GERE
6. *Something to Talk About* – Dennis QUAID
7. *The Ant Bully* – Nicolas CAGE
8. *The Mexican* – Brad PITT
9. *The Pelican Brief* – Denzel WASHINGTON
10. *Ticket to Paradise* – George CLOONEY
11. *Wonder* – Owen WILSON

The missing name is CAGE, who isn't 'seen' here as both actors had voice-only roles in this animated movie.

CHAPTER 3: SETTING THE SCENE

Page 67: Finding the Location
The Perfect Spot
There are fourteen location spots – the number of Oscars for which *La La Land* was nominated.

●	3	●	3		1	1
	3	●	●	3	●	
1		3	4	●	3	2
●	2	●			2	●
2			2			2
●	2		●	2	2	●
1		●	3	●		1

Page 69: *Inception*
Real and Unreal Locations

There are only six bridges that your path neither crosses over nor under, revealing that *Inception* was shot in six different countries. They are: Canada, France, Japan, Morocco, United Kingdom and United States.

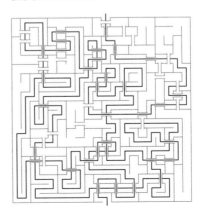

Page 71: Creating a World
Worlds Apart
1. *Apocalypse Now* – set in VIETNAM, filmed in the PHILIPPINES (E)
2. *Mad Max: Fury Road* – set in AUSTRALIA, filmed in NAMIBIA (D)
3. *The Mummy* – set in EGYPT, filmed in MOROCCO (A)
4. *Les Misérables* – set in FRANCE, filmed in ENGLAND (B)
5. *The Revenant* – set in the UNITED STATES, filmed in ARGENTINA (F)
6. *Gladiator* – set in ITALY, shot in MALTA (C)

Location Trivia
1. Los Angeles
2. Tokyo
3. Sydney
4. Edinburgh
5. Berlin
6. Barcelona
7. Paris
8. Rio de Janeiro
9. Mexico City
10. London

Page 73: *Parasite*
Stacked Odds

Bong Joon-ho estimated that it would take the character 540 years to save up to buy the house.

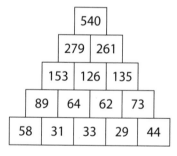

Bong Joon-ho Trivia
1. C. *Snowpiercer*
2. D. *Okja*
3. A. *Memories of Murder*
4. B. *The Host*

Page 75: Production Design
Same But Different
1. Quality Café – *Million Dollar Baby* and *Catch Me If You Can* (F)
2. Hatfield House – *The Favourite* and *Sherlock Holmes* (C)
3. Fox Plaza – *Speed* and *Die Hard* (B)
4. The Bradbury Building – *500 Days of Summer* and *The Artist* (G)

5. John Marshall High – *Grease* and *Pretty in Pink* (D)
6. The Cliffs of Moher – *The Princess Bride* and *Harry Potter and the Half-Blood Prince* (H)
7. Kilmainham Gaol – *Paddington 2* and *The Italian Job* (E)
8. Acton Lane Power Station – *Batman* and *Aliens* (A)

Page 77: *Ben Hur* and *Gladiator*
On a Biblical Scale
1. 11: The number of Oscars won by the film, including Best Picture
2. 200: The number of camels reportedly used for the film
3. 2,500: The number of horses reportedly used for the film
4. AD 26: The year in which the film's action begins

Page 79: Recreating the Past
All In Order
Gladiator – set in AD 180 (C)
The Adventures of Robin Hood – set in 1191 (A)
Shakespeare in Love – set in 1593 (S)
Marie Antoinette – set in the late 1770s (A)
Portrait of a Lady on Fire – set in the late 1800s (B)
Chicago – set in 1924 (L)
Hidden Figures – set in 1961 (A)
I, Tonya – set between 1974 and 1994 (N)
Metropolis – set in 2027 (C)
Interstellar – set in 2067 (A)

The name of the revealed film is *CASABLANCA* (1942). The film was shot, set and released during the Second World War, being banned in Ireland due to neutrality laws. A complete German version was only released in 1975.

Period Film Trivia
1. Paris; *Moulin Rouge!* (2001)
2. Indiana Jones; Harrison Ford
3. *The Piano* (1993)
4. *1917* and *Django Unchained*
5. Cyrano de Bergerac

Page 81: *The Leopard*
Having a Ball

Page 83: Costume Design
Best Dressed

A. *The Seven Year Itch* (1955) – The Girl, played by Marilyn Monroe
B. *Atonement* (2007) – Cecilia Tallis, played by Keira Knightley
C. *Pretty Woman* (1990) – Vivian Ward, played by Julia Roberts
D. *Breakfast at Tiffany's* – (1961) Holly Golightly, played by Audrey Hepburn

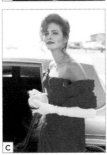
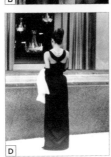

Page 85: The Batman Films
Find the Stars

Page 87: Make-Up
The Eyes Have It

A. Natalie Portman as Nina Sayers in *Black Swan* (2010)
B. Elizabeth Taylor as Cleopatra in *Cleopatra* (1963)
C. Heath Ledger as The Joker in *The Dark Knight* (2008)
D. Johnny Depp as The Mad Hatter in *Alice in Wonderland* (2010)
E. Michael Keaton as Beetlejuice in *Beetlejuice* (1988)

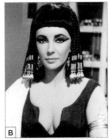

Page 89: Prosthetics
A Little Added Extra

1. Gary Oldman as Winston Churchill in *Darkest Hour*
2. Marlon Brando as Vito Corleone in *The Godfather*
3. Ian McDiarmid as Emperor Palpatine in *Star Wars: Return of the Jedi*
4. Nicole Kidman as Virginia Woolf in *The Hours*
5. Brendan Gleeson as Mad-Eye Moody in *Harry Potter and the Goblet of Fire*
6. Helena Bonham Carter as the Red Queen in *Alice in Wonderland*

Page 91: Special Effects
Digital Drawing
The sketch reveals a pterodactyl

Page 93: *No Time to Die*
Careful Chaos

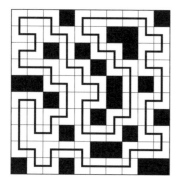

CHAPTER 4: THE DIRECTOR'S CHAIR

Page 97: Pioneers

Page 99: Charles Chaplin
Silent Chaplin
1. *THE RINK*
2. *THE CURE*
3. *THE BANK*
4. *THE COUNT*
5. *THE TRAMP*
6. *THE FIREMAN*
7. *THE VAGABOND*
8. *THE IMMIGRANT*
9. *THE KNOCKOUT*
10. *THE ADVENTURER*
11. *THE MASQUERADER*

Chaplin Trivia
1. *A Woman of Paris* (1923)
 Modern Times (1936)
 Monsieur Verdoux (1947)
 Limelight (1952)
2. Robert Downey Jr
3. London

Page 101: Alfred Hitchcock
Dating Hitchcock
A *Easy Virtue* (1928)
L *Blackmail* (1929)
M *The Man Who Knew Too Much* (1934)
A *The 39 Steps* (1935)
 Rebecca (1940)
R *Stage Fright* (1950)
E *Rear Window* (1954)
V *To Catch a Thief* (1955)
I *Vertigo* (1958)
L *North by Northwest* (1959)
L *Psycho* (1960)
E *The Birds* (1963)

The name of the collaborator is Alma Reville – Hitchcock's wife and creative collaborator.

Hitchcock Trivia
1. Cary Grant: *Notorious, To Catch a Thief;*
 James Stewart: *Rear Window, The Man Who Knew Too Much*
2. Tippi Hedren: *The Birds, Marnie*
 Joan Fontaine: *Rebecca, Suspicion*
 Ingrid Bergman: *Spellbound, Notorious*
 Grace Kelly: *Dial M for Murder, To Catch a Thief*

Page 103: Akira Kurosawa
Kurosawa Cuts
1. *No Regrets for Our Youth* (1946)
2. *Scandal* (1950)
3. *Seven Samurai* (1954)
4. *The Hidden Fortress* (1958)
5. *Throne of Blood* (1957)

Page 105: Stanley Kubrick
A Place for Everyone

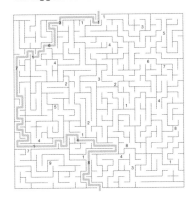

Page 107: Radical Waves
Mixed Movements

1. GERMAN EXPRESSIONISM – *Metropolis* – Fritz Lang (B)
2. FRENCH NEW WAVE – *Jules and Jim*, François Truffaut (A)
3. NEW HOLLYWOOD – *Taxi Driver* – Martin Scorsese (D)
4. ITALIAN NEOREALISM – *Rome, Open City* – Roberto Rossellini C)
5. SURREALISM – *Un Chien Andalou* – Luis Buñuel (F)
6. BRITISH NEW WAVE – *Tom Jones* – Tony Richardson (E)

Radical Wave Trivia

1. *Amadeus*
2. *Paris, Texas*
3. *If . . .*
4. *Bicycle Thieves*
5. *Nosferatu*

Page 109: Werner Herzog
Travelling Stories

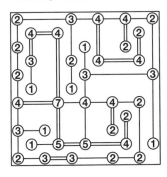

Page 111: Jean-Luc Goddard
Visible Cuts

Film title: *Contempt* (1963)
Lead actor: Brigitte Bardot
Location: Italy
Director/actor: Fritz Lang
Meta-film: *The Odyssey*

New Wave Trivia

Godard: *Breathless, Alphaville, Pierrot le Fou, Made in U.S.A, Weekend*
Truffaut: *The 400 Blows, Shoot the Pianist, Fahrenheit 451, The Bride Wore Black, Day for Night*

Page 113: Antonioni and Fellini
The Sweet Life

La Dolce Vita sold 13,617,148 tickets, making it one of the biggest box office hits in Italian cinema history.

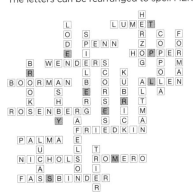

Page 115: Ingmar Bergman
Knight's Move

3	1	5	2	8	4	9	6	7
7	9	4	5	6	1	2	3	8
6	2	8	3	9	7	1	4	5
2	5	3	9	7	8	4	1	6
1	4	9	6	2	5	8	7	3
8	7	6	1	4	3	5	9	2
5	8	7	4	1	6	3	2	9
4	3	2	7	5	9	6	8	1
9	6	1	8	3	2	7	5	4

Page 117: New Generations
Lauded Legends

The letters can be rearranged to spell MERYL STREEP

Page 119: Martin Scorsese
Freeze Frame
A. *Taxi Driver* (1976)
B. *Raging Bull* (1980)
C. *The Irishman* (2019)
D. *New York, New York* (1977)

Page 121: Steven Spielberg
A Man of Many Talents: Spielberg Films

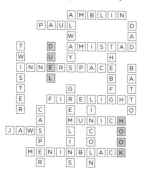

Page 123: Pedro Almodóvar
A World of Colour
1. *TALK TO HER* (2002) and SAPPHIRE (C)
2. *ALL ABOUT MY MOTHER* (1999) and VERMILION (A)
3. *VOLVER* (2006) and EMERALD (D)
4. *JULIETA* (2016) and LEMON (B)

Page 125: Spike Lee
Hiding in Plain Sight

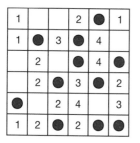

Page 127: Kathryn Bigelow
Point Break
Patrick Swayze made fifty-five skydives for the movie

Page 129: Quentin Tarantino
The Repertory
1. LEONARDO DICAPRIO + B
2. SAMUEL L JACKSON + R
3. KURT RUSSELL + A
4. CHRISTOPH WALTZ + D
5. UMA THURMAN + P
6. JOHN TRAVOLTA + I
7. LUCY LIU + T
8. JAMIE FOXX + T

The additional actor is Brad Pitt

Page 131: Park Chan-wook
Double Crossed

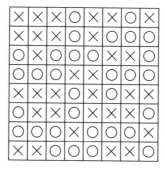

Page 133: Céline Sciamma
Hidden Talent
The revealed actor is Karidja Touré

K	U	P	E	I	R	D	S	J	T	O	A
D	A	S	O	E	P	T	J	R	I	U	K
I	T	R	J	A	U	K	O	D	E	P	S
E	R	J	I	P	T	O	K	S	A	D	U
O	K	T	U	D	I	S	A	P	J	E	R
P	D	A	S	R	J	E	U	T	K	I	O
R	I	U	T	O	D	A	P	E	S	K	J
J	O	K	P	S	E	I	T	U	R	A	D
S	E	D	A	U	K	J	R	O	P	T	I
A	P	O	D	K	S	R	E	I	U	J	T
T	S	E	K	J	O	U	I	A	D	R	P
U	J	I	R	T	A	P	D	K	O	S	E

Page 135: Christopher Nolan
A Numbers Game
1. The 14th: An unspecified date in *Tenet* around which the plot centres
2. 23: The number of years that are equivalent to one hour at a key point in *Interstellar*, due to time dilation caused by a black hole
3. 8: Bruce Wayne's age when his parents are killed in *Batman Begins*
4. 76: The unusually small number of pages in the script, which Nolan also wrote

Page 137: Actor-Directors
Seeing Double
A. Ben Stiller in *Zoolander* (2001)
B. Barbra Streisand in *Yentl* (1983)
C. Danny DeVito in *Matilda* (1996)
D. Denzel Washington in *Fences* (2016)

Page 139: Actor/Director Partnerships
Making Links
1. GT to DJ = Guillermo del Toro and Doug Jones
2. SC to KD = Sofia Coppola and Kirsten Dunst
3. SS to TH = Steven Spielberg and Tom Hanks
4. MS to RD = Martin Scorsese and Robert De Niro
5. QT to SJ = Quentin Tarantino and Samuel L Jackson
6. PA to PC = Pedro Almodóvar and Penelope Cruz
7. WA to BM = Wes Anderson and Bill Murray
8. WK to MC = Wong Kar-wai and Maggie Cheung

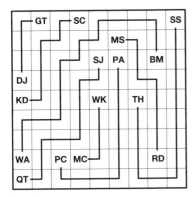

CHAPTER 5: IT'S A WRAP

Page 143: The Edit
Cut Together
1. *Ocean's Eleven*: George Clooney, Matt Damon, Brad Pitt, Don Cheadle (B)
2. *Knives Out*: Daniel Craig, Jamie Lee Curtis, Toni Collette, Christopher Plummer (C)
3. *Pulp Fiction*: John Travolta, Uma Thurman, Bruce Willis, Samuel L Jackson (A)
4. *Much Ado About Nothing*: Kenneth Branagh, Emma Thompson, Keanu Reeves, Denzel Washington (F)
5. *Spotlight*: Rachel McAdams, Mark Ruffalo, Michael Keaton, Stanley Tucci (E)
6. *12 Years a Slave*: Chiwetel Ejiofor, Lupita Nyong'o, Benedict Cumberbatch, Michael Fassbender (D)

Memorable Scenes Trivia
1. *Psycho* (1960)
2. *Lawrence of Arabia* (1962)
3. *The Untouchables* (1987)
4. *City of God* (2002)
5. *Bonnie and Clyde* (1967)
6. *2001: A Space Odyssey* (1968)

7. *Un Chien Andalou* (1929)
8. *The Matrix* (1999)
9. *The Godfather* (1972)
10. *Battleship Potemkin* (1925)

Page 145: *The Silence of the Lambs*
Redirect the Gaze

1 ⬇	10 ⬊	12 ⬊	8 ➡	9 ⬅
17 ⬇	5 ⬊	11 ⬆	7 ⬆	22 ⬉
2 ⬊	4 ⬆	14 ⬇	23 ⬉	13 ⬅
18 ➡	3 ⬆	21 ⬈	6 ⬆	19 ⬊
16 ⬆	24 ➡	15 ⬅	20 ⬋	25

Page 147: The Long Shot
Boiling Point

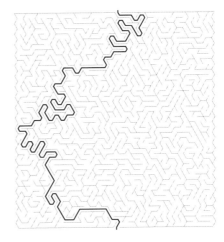

Page 149: A World of Sound
Natural and Unnatural
1. ALLIGATOR – T. rex in *Jurassic Park* (E)
2. COUGAR – Decepticon named Frenzy in *Transformers* (F)
3. CRAB – Ambient sound in Riley's mind in *Inside Out* (B)
4. ELEPHANT SEAL – Orc sounds in *The Lord of the Rings* series (D)
5. SWAN – Mountain Banshees in *Avatar* (A)
6. WALRUS – Wookiee language in *Star Wars* (C)

Sound Effects Trivia
1. A television; an old tube version of a TV was used to record microphone feedback

2. *E.T. the Extra-Terrestrial*
3. A dinosaur in *Jurassic Park*
4. *Raging Bull* (1980)
5. A melon

Page 151: *The Godfather*
Cut and Overlay
James CAAN is missing.

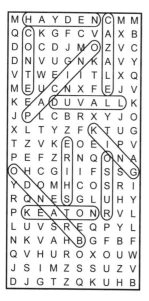

Page 153: Music
Sound and Vision
1. John Williams: 'Somewhere in My Memory' from *Home Alone* (B)
2. Hans Zimmer: 'Time' from *Inception* (C)
3. Alan Silvestri: ''85 Lone Pine Mall', from *Back to the Future* (A)
4. Bernard Herrman: 'Temptation' from *Psycho* (D)

Page 155: *2001: A Space Odyssey*
Spinning Waltz

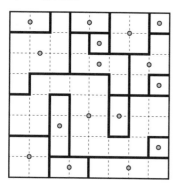

Page 157: Ennio Morricone
Back to the Beginning

Page 159: Visual Effects
Animal Antics
1. *The Golden Compass* (2007)
2. *Jurassic World* (2015)
3. *Life of Pi* (2012)
4. *The Revenant* (2015)

Page 161: James Cameron
A Deep Dive
A. *Avatar: Way of Water* (2022)
B. *Titanic* (1997)
C. *The Abyss* (1989)
D. *Aliens* (1986)

Cameron Trivia
1. Sarah Connor; B. *The Terminator*
2. Neytiri; D. *Avatar*
3. Dr. Lindsey Brigman; A. *The Abyss*
4. Ripley; C. *Aliens*
5. Helen Tasker; E. *True Lies*

CHAPTER 6: SELLING THE MOVIE

Page 165: The Artwork
Stark Contrasts
1. *The Graduate* (1967); D
2. *The Silence of the Lambs* (1991; B
3. *Rosemary's Baby* (1968); A
4. *Get Out* (2017); C

Page 167: *Alien*
Taglines
1. 'They're young, they're in love and they kill people' – *Bonnie and Clyde* (A)
2. 'The true story of a real fake' – *Catch Me If You Can* (B)
3. 'On the air. Unaware' – *The Truman Show* (G)
4. 'We are not alone' – *Close Encounters of the Third Kind* (C)

5. 'He may be dead – but he's the life of the party!'
 – *Weekend at Bernie's* (H)
6. 'One man's struggle to take it easy' – *Ferris Bueller's Day Off* (D)
7. 'The mission is a man' – *Saving Private Ryan* (F)
8. 'Everyone wants to be found' – *Lost in Translation* (E)

Page 169: The Critics
Everyone's a Critic
1. *Fight Club*: 61% male audience, leading to it being dubbed 'the ultimate anti-date flick'
2. *It's a Wonderful Life*: $525,000 box office loss for the film in US dollars
3. *The Shining*: Total number of Oscar, Golden Globe and BAFTA awards won: 0
4. *The Wizard of Oz*: Number of years passed before the film was considered to have turned a profit: 10

Page 171: The Festival Circuit
Completing the Circuit
The letters can be read to give the following order for the festival circuit:
S: Sundance – usually held in January
B: Berlin – usually held in February
C: Cannes – usually held in May
V: Venice – usually held in August
T: Toronto – usually held in September

Page 173: Cannes Film Festival
Winning Scenes
1. *The Class* (2008) – B
2. *The Piano* (1993) – A
3. *Blue is the Warmest Colour* (2013) – D
4. *I, Daniel Blake* (2016) – C

Page 175: The Awards Season
Eyes on the Prize
1. ARIEL – MEXICO
2. BLUE DRAGON – KOREA
3. CÉSAR – FRANCE
4. EAGLE - POLAND
5. GOLDEN HORN – SOUTH AFRICA
6. GOLDEN ROOSTER – CHINA
7. GOYA – SPAIN
8. LOLA – GERMANY
9. MACONDO – COLOMBIA
10. MAGRITTE – BELGIUM
11. OSCAR – USA
12. ROBERT – DENMARK
13. SOPHIA – PORTUGAL

Trophy Trivia
1. *Marty* and *Parasite*
2. They each won all five main category awards: Best Film, Best Director, Best Actress, Best Actor and Best Screenplay (original or adapted)

Page 177: Oscars
Line Them Up
1. Chloé Zhao – Best Director (B) – *Nomadland* (E)
2. Ben Kingsley – Best Actor (I) – *Gandhi* (I)
3. Emerald Fennell – Best Original Screenplay (L) – *Promising Young Woman* (L)
4. Frances McDormand – Best Actress (L) – *Fargo* (I)
5. Jenny Beavan – Best Costume Design (I) – *Cruella* (S)
6. Taika Waititi – Best Adapted Screenplay (E) – *Jojo Rabbit* (H)

The first artist born in the twenty-first century to win an Oscar is therefore BILLIE EILISH

Oscar Trivia
1. *Parasite* (2019)
2. Alfred Hitchcock
3. Marlon Brando
4. *La La Land* and *Moonlight*
5. Best Stunt Coordination

PICTURE CREDITS

Alamy: 7, 40 World History Archive; 10, 61 (A), 61 (D), 83 (D), 87 (D), 137 (D), 173 (D), 185l (D), 185r (D) Moviestore Collection Ltd; 12 Maximum Film/© WARNER BROS.; 14 Entertainment Pictures/Photo by United Artists/© 1966 by United Artists; 16 Collection Christophel © Mike Zoss Productions/Working title films; 18 Cinematic Collection/© THE WEINSTEIN COMPANY; 20, 58 Allstar Picture Library Limited/© UNIVERSAL PICTURES; 22 United Archives GmbH/IFA Film; 23 (A) Allstar Picture Library Limited/© IMAGE ENTERTAINMENT; 23 (B) TCD/Prod.DB /© Ameran; 23 (C), 62, 164 FlixPix/©UNIVERSAL PICTURES; 23 (D) Photo 12/MGM; 24, 52, 86, 98, 110 Everett Collection Inc; 26, 153 (A), 159 (B) Maximum Film/© UNIVERSAL PICTURES; 28 cineclassico; 30, 50, 137 (B), 153 (B) United Archives GmbH/kpa Publicity Stills; 32, 42, 54, 80, 88, 119 (B), 146, 153 (D), 154, 161 (A) Pictorial Press Ltd; 36 GRANGER - Historical Picture Archive; 38, 46, 61 (E), 87 (B), 114, 126, 158, 165 (C), 173 (A), 185r (B) PictureLux/The Hollywood Archive; 44 ScreenProd/Photononstop; 60 London Entertainment; 61 (B) Album/PARAMOUNT PICTURES; 61 (C) AJ Pics/© COLUMBIA; 61 (F) Maximum Film/© PARAMOUNT PICTURES; 83 (C), 185l (C) Album/TOUCHSTONE/WARNERS; 66 TCD/Prod.DB/© Warner Bros.; 68, 153 (C) TCD/Prod.DB © Warner Bros. Pictures - Legendary Pictures; 70 Entertainment Pictures/© BBC Films; 72 Everett Collection Inc/© Neon; 74, 87 (E), 185r (E) Allstar Picture Library Limited/© WARNER BROS.; 76 Ivan Batinic; 78 Album/ELEMENT PICTURES/SCARLET FILMS/FILM4/WAYPOINT ENTERTAINMENT; 82 Album/20TH CENTURY FOX; 83 (A), 185l (A) CBW; 83 (B), 185l (B) Album/WORKING TITLE FILMS; 84 Album/DC ENTERTAINMENT/WARNER BROS.; 87 (A), 185r (A) AJ Pics/© FOX SEARCHLIGHT 2JDPJ2T; 87 (C), 104, 136, 185r (C) AJ Pics/© WARNER BROS.; 90, 122 Entertainment Pictures; 92 TCD/Prod.DB © Danjaq - Metro-Goldwyn-Mayer (MGM) - Universal Pictures - Eon Productions; 96 Lebrecht Music & Arts; 100 IanDagnall Computing; 102, Allstar Picture Library Limited/© COLUMBIA; 108 Album/METRO GOLDWYN; 116 Ralph Dominguez/MediaPunch; 119 (A) TCD/Prod.DB © Columbia Pictures; 118 Atlaspix; 119 (C) TCD/Prod.DB © Netflix - Fabrica de Cine - STX Entertainment - Sikelia Productions - Tribeca Productions; 119 (D) TCD/Prod.DB © United Artists; 120 Everett Collection Inc/Steven Ferdman; 123 (A) AJ Pics © El Deseo 2JD8CWT; 123 (B) Collection Christophel © El Deseo; 123 (C) Album/EL DESEO S.A / BRACHO, MIGUEL; 123 (D) AJ Pics/© SONY PICTURES CLASSICS; 124 © Courtesy of 40 Acres & a Mule Fi/Entertainment Pictures; 128 Everett Collection Inc/Francois Duhamel/© Weinstein Company; 130, 138 Photo 12; 132 TCD/Prod.DB © Lilies Films - Arte Fran; 137 (A) AJ Pics/© PARAMOUNT; 137 (C) Album/TRISTAR PICTURES; 142 Science History Images; 144, 165 (B) Maximum Film/© ORION PICTURES; 148 TCD/Prod DB © Third Man Films - Pinewood Studios / DR Third Man Films; 150 LANDMARK MEDIA/© Paramount Pictures; 152 Jonathan Player; 156 Universal Images Group North America LLC; 159 (A) Maximum Film ©NEW LINE CINEMA; 159 (C) FlixPix © Fox 2000 Pictures; 159 (D) TCD/Prod.DB © 20th Century Fox - New Regency Pictures - Anonymous Content - RatPac Entertainment; 160 Maximum Film © 20TH CENTURY FOX; 161 (B) United Archives GmbH/Impress; 161 (C), 161 (D) Allstar Picture Library Limited/© 20th Century Fox; 165 (A) MARKA/mrk movie; 165 (D) BFA/Universal Pictures; 166 Everett Collection, Inc./© 20th Century Fox Film Corp; 168 Everett Collection Inc/©Samuel Goldwyn; 173 (B) Maximum Film/©HAUT ET COURT; 173 (C) Album/BBC/BFI/LES FILMS DU FLEUVE/SIXTEEN FILMS/WHY NOT PROD/WILD; 174 Abaca Press/Alamy Live News. **Getty Images:** 106 Gilbert TOURTE; 112 Reporters Associati & Archivi; 176 Rich Polk. **Noun Project:** 64: Aldric Rodríguez; 94: Icongeek26; 140: yudi susanto; 162: Vectors Point. **Shutterstock:** 8, 34: keenani; 21 Germany, UK ElenVD; Japan OneLineStock, ; Spain PVLGT; Sweden SKARIDA; USA 4zevar; 48 Oleg Nikishin; 56 Block 2 Pics/Jet Tone/Kobal; 134 BAKOUNINE; 170 taniavolobueva; 172 Balkis Press/ABACA.

Front cover: VectorPortal.

Back cover, top to bottom: Alamy: Pictorial Press Ltd; Atlaspix; Pictorial Press Ltd; Everett Collection Inc/Francois Duhamel/©Weinstein Company.

While every effort has been made to credit photographers, Quarto would like to apologize should there have been any omissions or errors, and would be pleased to make the appropriate correction for future editions of the book.